This is
Warhol

Published in 2014 by
Laurence King Publishing
361–373 City Road
London EC1V 1LR
United Kingdom
T +44 20 7841 6900
F +44 20 7841 6910
enquiries@laurenceking.com
www.laurenceking.com

A catalogue record for this book is available from the
British Library.

ISBN: 978 1 78067 014 0

Cover designed by Pentagram Design and
Alex Coco, based on an original concept by
Melanie Mues. Illustration by Andrew Rae.

Book design: Jason Ribeiro

Series editor: Catherine Ingram

Printed in Hong Kong

This is
Warhol

CATHERINE INGRAM
Illustrations by ANDREW RAE

LAURENCE KING PUBLISHING

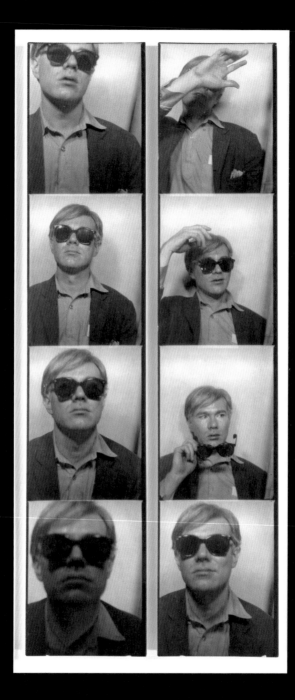

Photobooth Self-Portrait
Andy Warhol, c. 1963

Gelatin silver print
7¾ × 1⁷⁄₁₀ in (19.6 × 3.6 cm) each
The Metropolitan Museum of Art, Purchase, Rogers Fund,
Joyce and Robert Menschel, Adriana and Robert Mnuchin, Harry Kahn,
and Anonymous Gifts, in memory of Eugene Schwartz, 1996. Acc. n.: 1996.63a,b.

Andy Warhol is shown in two Polaroid strips: the awkward kid turned New York hotshot, looking cool, with shades and silver hair. As the camera snaps automatically, Warhol plays around, twisting his seat up and down and posing for the camera. Typically, he denies us intimacy: in six of the frames he hides behind large, black shades; when his glasses are off, he covers his face with his hand, or looks sideways, off-camera.

The self-portrait is a radical piece of art that embraces popular culture. Warhol uses a photo booth – the public camera found in railway stations and shopping malls that delivers cheap photos, 'four-for-a-quarter' – and finds beauty in the throwaway, the intense, almost square frame and the sequence of stills, depicting a development in time.

Warhol promises nothing more than what the photomat delivers: 'If you want to know all about Andy Warhol, just look at the surface of my paintings and films and me, and there I am. There's nothing behind it.' However, that glossy surface is provocative. Described by many as a mirror, Warhol reflects the vacuousness of modern society in high resolution.

The chimneys of Pittsburgh

Andy Warhol was born on 6 August 1928 in Pittsburgh. His parents,
Julia and Ondrej Warhola, came from a Rusyn mountain village in
Czechoslovakia (present-day eastern Slovakia). With children growing
up during the Depression years, Andy's family isolated themselves
from Pittsburgh's macho blue-collar culture, and lived within a largely
Carpatho-Rusyn community. At home they spoke in their mother tongue,
and Julia would recount old village tales, and sing traditional folk songs.
Andy liked to wander through the 'Czech ghetto with the babushkas and
overalls on the clothes lines'. Later, living in New York, he would listen to
tapes of his mother singing Rusyn songs.

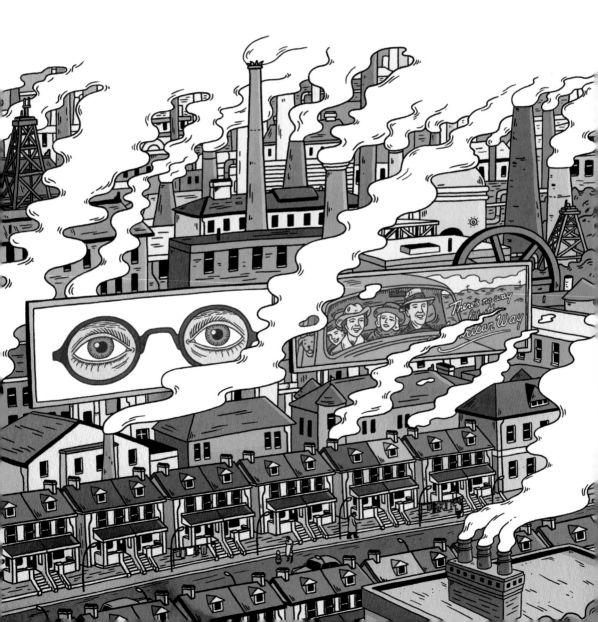

The Church of St John

The family moved five times in the first six years of Andy's life. In 1934 Ondrej bought a yellow brick house at 3252 Dawson Street, within walking distance of St John Chrysostom Byzantine Catholic Church, where the family worshipped twice a week.

Central to Catholic faith is the icon, which offers the believer a living encounter with a holy being. St John's boasts an entire gilded wall of icons. Hour after hour Warhol would stare at these flat, highly coloured figures. Later he would paint modern icons. Brutally flat, his depictions of Campbell's soup cans and Hollywood stars shine out like the saints at St John's.

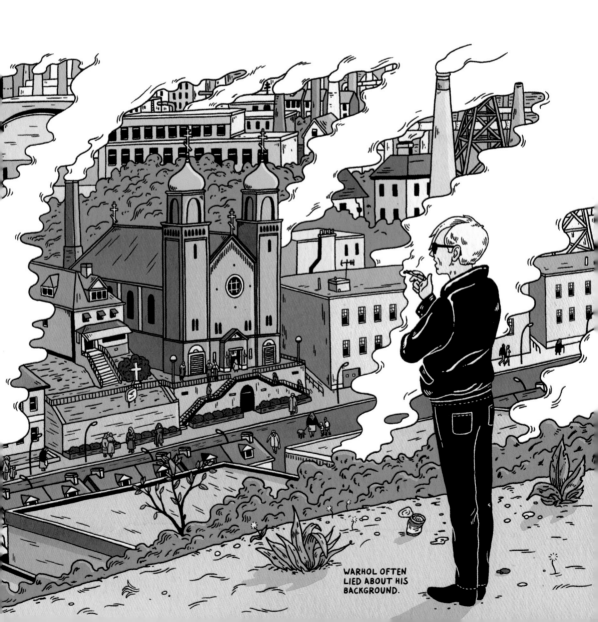

WARHOL OFTEN LIED ABOUT HIS BACKGROUND.

Julia

Julia and Ondrej's first child, a baby girl, died before they left for America. Andy, the youngest of three boys and a sickly child, seemed to get most of the attention, as Julia tells: 'Andy's my baby. My other baby, a daughter, she die when my husband left … Andy my baby now.'

Julia was a talented artist. She started off with homespun projects, making art from bits of rubbish, decorating Easter eggs with hot wax and embroidering fabrics. She was always drawing. According to John, the second eldest child, 'we all drew'. In 1954 Julia published *Holy Cats*, a folio of drawings of fanciful cats and angels. She also had very distinctive writing and worked as a graphic designer, winning an award for her lettering on an album cover for Moondog. Julia did most of the lettering on Andy's early commercials.

Despite her gifts, Warhol was embarrassed by his mother, who referred to herself as 'the old peasant woman'. Much later when Julia moved to New York, Andy tried to transform her babushka image with shopping sprees to Macy's. In their grand New York residence, Julia lived 'downstairs', slightly hidden away.

The cocoon

At 8 years old Andy contracted St Vitus' Dance disorder, or chorea, and was bedridden for ten weeks. The illness left him with nervous tremors, a red mark across his cheek, and a scarred scrotum, which, according to his doctor, he was deeply ashamed about, and which made him fearful of undressing and exposing himself. The next two summers he fell ill again, as he tells: '[it] always started on the first day of summer vacation. I don't know what this meant. I would spend all summer listening to the radio.' Andy didn't play with the kids outside. Instead, his brothers sat on his bed and taught him to trace and draw, and Julia read him his favourite comic books. He lived in a sort of fantasy world inhabited by the comic heroes and the Hollywood stars that hung round his bed.

In 1942 Ondrej died unexpectedly after drinking poisoned water at a construction site. Warhol was 14 years old. Overwhelmed, he hid under his bed, and refused to look at his father in the open casket. Julia decided that he should not attend his father's funeral because of his 'nervous condition'. Warhol had a lasting fear of illness, and death. Death is a central undercurrent in his art.

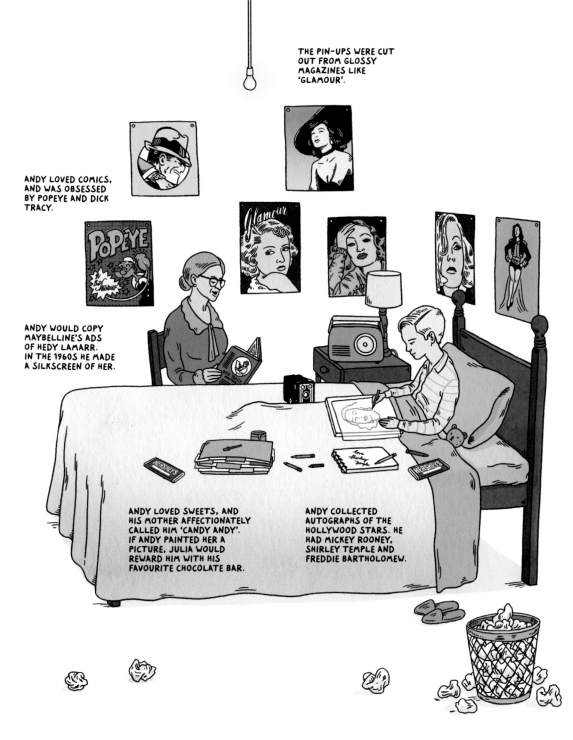

THE PIN-UPS WERE CUT OUT FROM GLOSSY MAGAZINES LIKE 'GLAMOUR'.

ANDY LOVED COMICS, AND WAS OBSESSED BY POPEYE AND DICK TRACY.

ANDY WOULD COPY MAYBELLINE'S ADS OF HEDY LAMARR. IN THE 1960S HE MADE A SILKSCREEN OF HER.

ANDY LOVED SWEETS, AND HIS MOTHER AFFECTIONATELY CALLED HIM 'CANDY ANDY'. IF ANDY PAINTED HER A PICTURE, JULIA WOULD REWARD HIM WITH HIS FAVOURITE CHOCOLATE BAR.

ANDY COLLECTED AUTOGRAPHS OF THE HOLLYWOOD STARS. HE HAD MICKEY ROONEY, SHIRLEY TEMPLE AND FREDDIE BARTHOLOMEW.

A commercial start in art

In the Warhol home, art was not just about soul searching; it was a serious activity that could earn money. In hard times, Warhol saw his mother make flowers from tin cans and sell them to his neighbours, and he followed her example. In the holidays he helped his brother sell fruit and veg from the back of a truck, and picked up extra money sketching the customers' portraits. In these early, mundane jobs, Warhol reveals his true self. His aesthetic eye, social aspirations and love of money are all evident. When the 'poor kid' started work at a five-dime store, the lines of sparkling, new products mesmerized him, and he thought: '[the place] was beautiful, like heaven.'

Later, at art school, Warhol dressed the windows at Joseph Horne's Department Store. The iconic seven-storey shop was the first department store in downtown Pittsburgh, and every year people would flock to see their gigantic Christmas tree that soared up to the roof. For 50 cents an hour, taking ideas from the glossy magazines, Warhol learnt how to advertise products, and endow ordinary things with fantasy and desire. French philosopher and cultural theorist Jean Baudrillard argued that 'Advertising is … pure connotation'. Warhol believed in the mythology: the consumer product, just like the pin-ups round his bed, signified something special. In the 1950s Warhol went on to dress the windows of Bonwit Teller, the salubrious, high-end fashion store on Fifth Avenue.

The shop-window experience echoes Warhol's personal life. He struggled with intimate relationships and, like the window shopper, was more of a voyeur on the world: 'I'm the type who'd like to sit home and watch every party that I'm invited to on a monitor in my bedroom.' Extending the mythology of the branded product, he idolized people as symbols of perfection, believing that, 'Fantasy love is much better than reality love. Never doing it is very exciting. The most exciting attractions are between two opposites that never meet.'

School life

Andy never settled at primary school; he struggled with the work and found it difficult to make friends. His secondary school, Schenley High School, was a far more positive experience, and Andy formed his first friendship with a girl called Eleanor Simon. A year and a half older than Andy, Eleanor was like a protective, older sister. She helped Andy with his schoolwork, his confidence improved enormously, and he ended up graduating in the top third of his class. Slowly Andy emerged from the cocoon that Julia had built for him. He began to feel more comfortable.

While Andy was attending Schenley High, he won a scholarship place on a drawing class for gifted children at the Carnegie Institute. A number of famous American artists emerged from this course, and tutor Joseph Fitzpatrick recognized the challenging atmosphere: 'We expected a lot from them, and we got it.' According to Fitzpatrick, Andy's talent was immediately spotted: 'I distinctly remember how individual and unique his style was … From the very start he was original.'

These art classes introduced Warhol to a new world, one of privilege and wealth. The Museum's Hall of Sculpture housed casts of iconic classical and Egyptian sculptures, while the Hall of Architecture displayed examples of the monumental façades of Europe. Warhol was impressed, but especially by the rich kids who attended the classes: years later he remembered their fancy cars and the 'mothers who wore expensively tailored clothes and glittery jewels'.

Carnegie Tech 1945–49

Andy's father's death released insurance money, which was used to pay for Andy's college fees. In September 1945 Andy started at Carnegie Tech. The college taught fine art and modern design. Professor Robert Lepper described the scene: 'One half of my class wanted to be "serious" artists, and were regarded as snobs by those like Andy, who wanted to do commercial design. It was my job to make them lie down together.' Warhol majored in pictorial design, and was awarded his BA in 1949. He also dabbled with the 'serious' side, and his paintings from this period are expressive: lonely characters are set in empty spaces, and the brushwork is agitated and raw.

While at art school Warhol drew his professor. With short, spiky hair, arty glasses and flaming nostrils, Lepper looks provocative and youthful. He sticks his tongue out and flicks the V sign. The execution is vibrant. A series of pointed triangles (repeated in the tongue, the fingers and the shirt collars) contrasts with the bristly stroke used in the moustache and hair. Emerging from the cocoon, Warhol seems dazzled by the energy and freedom at art school. In contrast to the rarified culture of traditional art schools, Lepper was accessible, and his references were popular ('I was raised on the American Boy and The Saturday Evening Post'). He was the perfect teacher for the student who would go on to paint soup cans.

Warhol enjoyed Carnegie Tech. He had a number of friends on his course. He hung out at the Modern Dance Club, and even performed at their final show. At the height of his career, Warhol coyly remarked, 'I never wanted to be a painter. I wanted to be a tap dancer.' As Warhol became absorbed in college life, he ignored his mother. Perhaps feeling left out, Julia did not pay his third-year fees, leaving Andy to scrape together enough money to continue his course. In his final year Warhol started working on a blotted-line technique that would become his signature style as a commercial artist. Warhol was ready to move on.

Robert Lepper, Untitled (Caricature of Robert Lepper)
Andy Warhol, 1948–49

Graphite on bond paper
11 × 8½ in (27.9 × 21.6 cm)
The Andy Warhol Museum, Pittsburgh; Founding Collection,
Contribution The Andy Warhol Foundation for the Visual Arts, Inc.

THE BIG APPLE

IN 1949, AFTER GRADUATING FROM CARNEGIE TECH, WARHOL LEFT PITTSBURGH. HE RECOUNTS, 'WHEN I WAS 18 A FRIEND STUFFED ME INTO A KROGER'S SHOPPING BAG AND TOOK ME TO NEW YORK.' HE WAS THRILLED TO BE A NEW YORKER. HE RENTED A CHEAP APARTMENT IN TRENDY MANHATTAN WITH HIS COLLEGE FRIEND PHILIP PEARLSTEIN. HIS GLAMOROUS NEW LIFE REFLECTED MANY OF HIS CHILDHOOD PASSIONS.

STALKER

WARHOL HUNG AROUND TRUMAN CAPOTE'S PARK AVENUE APARTMENT, HOPING TO BUMP INTO THE FAMOUS AUTHOR.

STARGAZER

WARHOL WOULD SIT IN THE LOBBY OF THE PLAZA HOTEL, SPOTTING STARS.

COCKROACHES

WARHOL'S FIRST FLAT WAS RIDDEN WITH COCKROACHES. AT HIS FIRST INTERVIEW, COCKROACHES FELL OUT OF HIS BAG AND SCUTTLED ACROSS THE DESK.

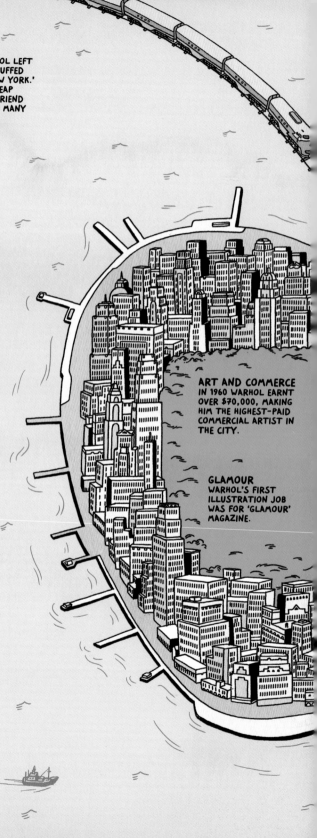

ART AND COMMERCE

IN 1960 WARHOL EARNT OVER $70,000, MAKING HIM THE HIGHEST-PAID COMMERCIAL ARTIST IN THE CITY.

GLAMOUR

WARHOL'S FIRST ILLUSTRATION JOB WAS FOR 'GLAMOUR' MAGAZINE.

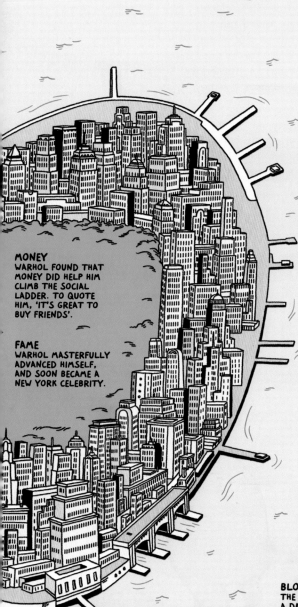

MONEY
WARHOL FOUND THAT MONEY DID HELP HIM CLIMB THE SOCIAL LADDER. TO QUOTE HIM, 'IT'S GREAT TO BUY FRIENDS'.

FAME
WARHOL MASTERFULLY ADVANCED HIMSELF, AND SOON BECAME A NEW YORK CELEBRITY.

MOTHER
IN 1952 JULIA MOVED TO NEW YORK. SHE LIVED WITH ANDY UNTIL 1970, WHEN SHE WAS LOOKED AFTER IN A CARE HOME.

HIGH DINING FOR TWO
WARHOL LIKED TO DINE IN NEW YORK'S FINEST RESTAURANTS. OFTEN HE ORDERED FOR TWO, AND HAD ONE OF THE MEALS PUT IN A DOGGIE BAG, WHICH HE GAVE TO A HOMELESS PERSON ON THE WAY HOME.

BLOOMINGDALE'S
THE ICONIC NEW YORK STORE WAS A DAILY PIT STOP FOR WARHOL. HE WOULD CHAT AWAY WITH THE SALES ASSISTANTS.

Commercial work

Warhol was extremely successful as a commercial artist. His first job was for *Glamour* magazine, and he went on to work for all the major fashion magazines, including *Vogue* and *Harper's Bazaar.* Andy had a boyish appeal, and clients called him Raggedy Andy, because he looked so scruffy in his T-shirt and chinos. He would turn up to meetings with his work in a paper bag, earning him his other nickname: Andy Paperbag. In time he smartened himself up and dressed like the rest of Madison Avenue, with the tailored suit and Italian shoes. But Warhol understood the power of the Raggedy Andy image, and he incorporated a scruffy edge to his dandy look, encouraging his cats to pee on his shoes so that they looked worn out.

Warhol offered something different from the slick ads of the day. His blotted-line drawings have a loose, naive quality. Paradoxically, the execution of these informal drawings was incredibly complicated. Warhol would make a simple drawing that he would trace over with fountain pen. While the ink was still wet, he would take an imprint of the original. This method allowed him to make multiple copies.

Wild Raspberries

Andy's illustrations for the cookbook *Wild Raspberries* are lively and varied. Sometimes the dribbled line is thick, in other places it is whisper thin. The radiating lines around the plate in this illustration break up into staccato dashes, while certain lines arch round in a sinuous flow. The vibrant pink wash is candy sweet: you can almost taste the jelly. Julia Warhola added the handwriting.

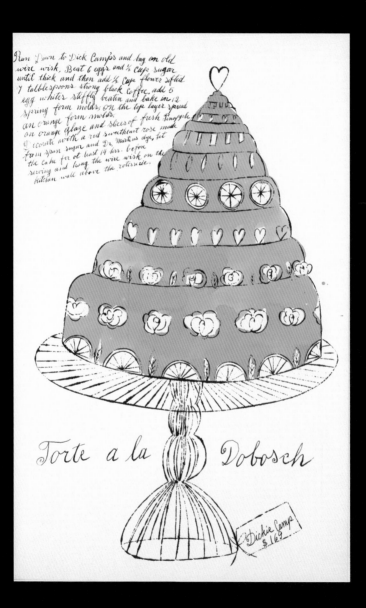

Wild Raspberries
Andy Warhol (illustrator) and Suzie Frankfurt (author), 1959

Offset lithograph and watercolour on paper
17¼ × 10¾ in (43.49 × 27. 3 cm)

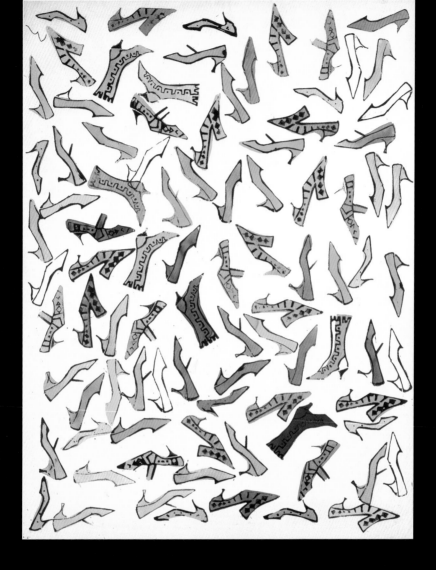

Untitled (Stamped Shoes)
Andy Warhol, c. 1959

Ink and Dr. Martin's Aniline Dye on ivory sketchbook paper
23¾ × 17⅞ in (60.3 × 45.4 cm)

A miniature factory

Central to the Warhol mythology is the Factory, and the team of workers that produced the multiple silkscreens. In the 1950s there was a scaled-down version in operation: Warhol employed his friend Nathan Gluck to draw up the illustrations while his mother added the lettering. In the commercial world, collaborative work is standard practice, but in fine art one expects only the authentic mark of the artist, as philosopher Arthur Danto reflects: 'We think of Michelangelo … creating unique objects of beauty and meaning.' The Abstract Expressionists pushed the idea that their creative process was an expression of their inner soul. Warhol put an end to this drama. Anyone could make his work.

A foot fetish

In the mid 1950s Warhol secured a lucrative deal with the shoe company I. Miller, who asked him to revamp their look with a weekly advert in *The New York Times*. Had the company heard that Warhol had a foot fetish? His boyfriend, John Giorno, amusingly confirms the rumour: 'I was sitting on a seventeenth-century Spanish chair … and suddenly Andy was on the floor with his hands on my feet, and started kissing and licking my shoes.' Warhol transformed women's perceptions of Miller shoes, making them seem fashionable and modern. In the drawing opposite, an array of brightly coloured boots and shoes tumble through a crisp, white space, and there are definitely fetishistic overtones to the pointed toes, snappy heels and embroidered boots.

In the process of working on the Miller ads, Warhol discovered the benefit of showing multiples, as he tells: 'I was working on shoes and I got $13 a shoe; so I had to think in terms of $13 for every shoe. If they gave me 20 shoes to do for an ad, it was 20 times $13.' In the 1960s he would go on to use repeated motifs in his silkscreens, and sell multiple editions of each silkscreen. It was another provocative gesture towards the art world, challenging the idea of art as a unique object.

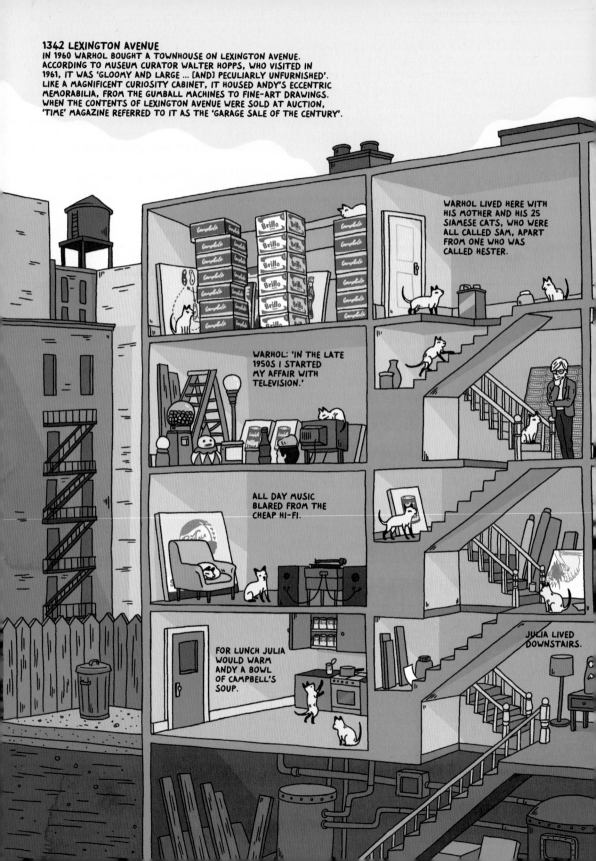

1342 LEXINGTON AVENUE
IN 1960 WARHOL BOUGHT A TOWNHOUSE ON LEXINGTON AVENUE. ACCORDING TO MUSEUM CURATOR WALTER HOPPS, WHO VISITED IN 1961, IT WAS 'GLOOMY AND LARGE ... [AND] PECULIARLY UNFURNISHED'. LIKE A MAGNIFICENT CURIOSITY CABINET, IT HOUSED ANDY'S ECCENTRIC MEMORABILIA, FROM THE GUMBALL MACHINES TO FINE-ART DRAWINGS. WHEN THE CONTENTS OF LEXINGTON AVENUE WERE SOLD AT AUCTION, 'TIME' MAGAZINE REFERRED TO IT AS THE 'GARAGE SALE OF THE CENTURY'.

WARHOL LIVED HERE WITH HIS MOTHER AND HIS 25 SIAMESE CATS, WHO WERE ALL CALLED SAM, APART FROM ONE WHO WAS CALLED HESTER.

WARHOL: 'IN THE LATE 1950S I STARTED MY AFFAIR WITH TELEVISION.'

ALL DAY MUSIC BLARED FROM THE CHEAP HI-FI.

FOR LUNCH JULIA WOULD WARM ANDY A BOWL OF CAMPBELL'S SOUP.

JULIA LIVED DOWNSTAIRS.

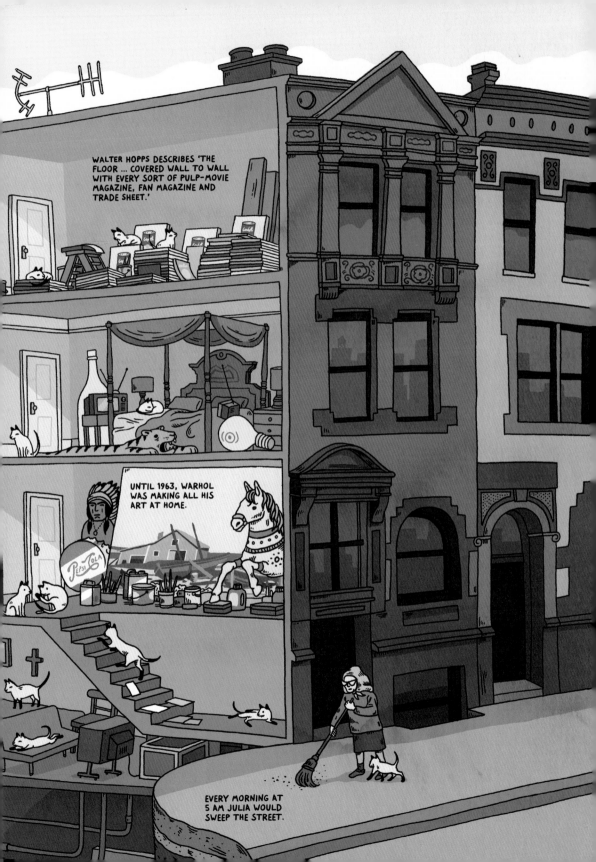

WALTER HOPPS DESCRIBES 'THE FLOOR ... COVERED WALL TO WALL WITH EVERY SORT OF PULP-MOVIE MAGAZINE, FAN MAGAZINE AND TRADE SHEET.'

UNTIL 1963, WARHOL WAS MAKING ALL HIS ART AT HOME.

EVERY MORNING AT 5 AM JULIA WOULD SWEEP THE STREET.

The serious side of art

In the late 1950s Warhol started thinking more about the 'serious' side: fine art. The art world was experiencing a time of great change, and artists were questioning Abstract Expressionism, which had dominated the scene for years. The feeling was that the Expressionists' intense soul searching had lost touch with reality and everyday experience. Their expressive idioms – moody colours and cathartic marks – seemed embarrassing to the new generation.

Robert Rauschenberg and Jasper Johns marked a change in tide. Their gritty work focused on their surroundings: Rauschenberg put real things in his paintings, including splodges of toothpaste, a quilt, old newspapers and even a dead bird; while Johns painted everyday images, letters, targets and flags. Warhol's friend Emile de Antonio – an art agent – was a staunch supporter of Johns and Rauschenberg. De Antonio would gossip with Warhol about having dinner with Johns and Rauschenberg in front of 'the big American flag, the first Targets, the first Numbers', and celebrity worshipper Warhol soaked it up: 'For me, just thinking about what that must have been like was thrilling.' According to Warhol, their idle gossip provided his art training.

The Beat Generation, a group of post-war American writers, provided another important background. They describe a similarly raw, modern America. In *Howl*, poet Allen Ginsberg evokes a druggy, nocturnal world, a world not dissimilar to the scene later at Warhol's Silver Factory. In the 1960s the Beat poets hung out at Andy's Silver Factory, and Andy shot short films of Ginsberg and Jack Kerouac.

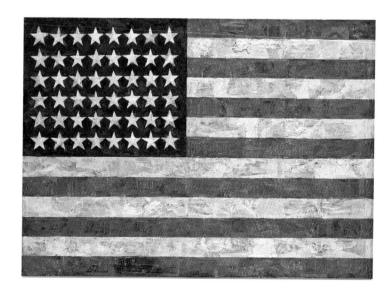

Jasper Johns, *Flag*, 1954
Dated on reverse. Encaustic, oil and collage on fabric mounted on plywood, 42¼ × 60⅜ in (107.3 × 153.8 cm). Museum of Modern Art, New York. Gift of Philip Johnson in honor of Alfred H. Barr, Jr. 106.1973.

Pop art

Warhol became part of the Pop art scene in New York in the early 1960s. Along with Andy the chief players were Claes Oldenburg, Tom Wesselmann, James Rosenquist and Roy Lichtenstein. Working independently of each other, they emerged with a common outlook. Henry Geldzahler, then curator of twentieth-century art at the Metropolitan Museum of Art, described the beginnings: 'It was like a science-fiction movie – you Pop artists in different parts of the city, unknown to each other, rising out of the muck and staggering forward with your paintings in front of you.'

The American Pop artists had radical intentions. Like Johns and Rauschenberg, they rebelled against the established art world, its rarified atmosphere and elitist cultural references. Pop art did not require prior knowledge. It was easy, immediate and fun. They celebrated everyday, modern life. As Warhol put it: 'The Pop artists did images that anybody walking down Broadway could recognize in a split second – comics, picnic tables, men's trousers, celebrities, shower curtains, refrigerators, Coke bottles – all the great modern things that the Abstract Expressionists tried so hard not to notice at all.'

Their art was for the ordinary man. More than a 'New York' thing, it was about being American. When Warhol took a road trip (the great American pastime) he observed a 'Pop' quality to every highway sign and billboard across the country, as he describes: 'The farther west we drove, the more Pop everything looked on the highways … we all felt like insiders.' Indeed, according to Warhol, 'Pop America was America.'

The electronic revolution

The Pop artists embraced the experience of living in an electronic age. Americans were being bombarded by new images and sounds. Black-and-white TV, vinyl record players, personal tape recorders, portable radios and instant cameras were hitting the market, and finding their place in most homes. From their sitting room, the nation watched the first TV debate between presidential candidates John F. Kennedy and Richard Nixon, and a few years later witnessed President Kennedy shot down dead. In 1969 the whole world tuned into the live broadcast of the Eagle landing and saw Neil Armstrong take man's first steps on the moon.

Philosopher Marshall McLuhan would argue that the electronic revolution 'constitutes a total and near-instantaneous transformation of culture, values and attitudes.' Andy was thrilled by the new experience. He would 'fantasize about what I would do if I were President – how I would use my TV time.' Actor Tom Lacy remembers being in a lift with Andy and hearing the first muzak; the two of them slow danced until they reached their floor. Warhol snapped up all the latest devices. At home the TV, hi-fi and radio constantly played in the background, and at parties, rather than chatting to people, Warhol would click away on his camera or press play on his tape deck.

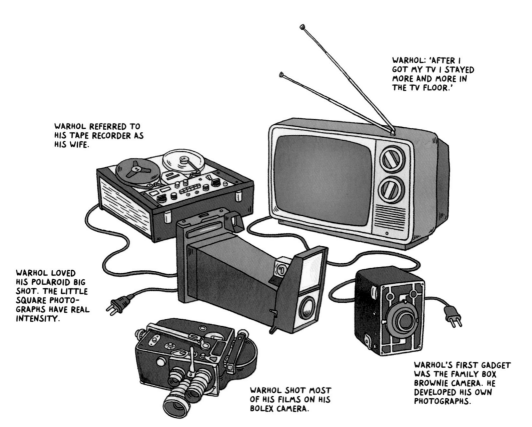

WARHOL: 'AFTER I GOT MY TV I STAYED MORE AND MORE IN THE TV FLOOR.'

WARHOL REFERRED TO HIS TAPE RECORDER AS HIS WIFE.

WARHOL LOVED HIS POLAROID BIG SHOT. THE LITTLE SQUARE PHOTO-GRAPHS HAVE REAL INTENSITY.

WARHOL SHOT MOST OF HIS FILMS ON HIS BOLEX CAMERA.

WARHOL'S FIRST GADGET WAS THE FAMILY BOX BROWNIE CAMERA. HE DEVELOPED HIS OWN PHOTOGRAPHS.

A first pop

Warhol's first Pop paintings were based on adverts and comic strips, at the time regarded as throwaway images. In 1960 he painted his childhood hero Dick Tracy. Referencing a comic book was a radical move. The creator of Dick Tracy, Chester Gould, evoked a society gone awry, a crime-invested America. He based his 'bad guys' on gangsters that he read about in the newspaper, while his villain Bomb Face, with his cannonball head, visualized the looming threat of world war.

The story of Dick Tracy is about an outsider culture. The hard-hitting secret detective is a rebel, an urban cowboy, who takes the law into his own hands. Employing all the latest gadgetry, Tracy has great Pop appeal. Communication has the grittiness of Ginsberg's *Howl* – the landscape is everyday life, the pace is hurried and the characters speak out in bold exclamations. Warhol captures Tracy's brutish looks: his signature crooked nose and angular jaw line, and he reproduces Gould's bold use of colour. Interestingly, Warhol was criticised for not going far enough. Ignoring the flat graphics, Warhol's execution is textured and rather painterly: Dick Tracy's face and the green background are scored with hatched lines, while dribbles of paint run off the brim of Tracy's hat, and the bottom of his jacket.

In 1961 Ivan Karp, co-director of the Leo Castelli Gallery, visited Warhol at Lexington Avenue. It was an important meeting, because it could have secured a gallery deal for Warhol. According to Karp, he looked through '30 or 40 paintings of various cartoon subjects, some done in the Abstract Expressionist style and some very plain and numb'. Karp didn't offer a deal, but he gave Warhol some clear advice: 'I told him that I preferred the works without the splashes and splatterings, that if one were to work in a cartoon style … one might as well go all the way.'

Warhol's art agent friend Emile de Antonio was of the same opinion. A year earlier Andy had shown him two paintings of Coke bottles, one in an Abstract Expressionist style, and the other with the hard-edge graphics of the Coke bottle. De Antonio said bluntly: 'Come on, Andy, the abstract [Abstract Expressionist] one is a piece of shit, the other one is remarkable. It's our society, it's who we are, it's absolutely beautiful and naked.' Subsequently, Warhol eliminated the personal touches – the dribbled paint and gestural brushwork – and focused on popular visual idioms. But Pop artist Roy Lichtenstein was ahead of the game; he'd already nailed the comic-book look.

Dick Tracy
Andy Warhol, 1960

Casein and wax crayon on canvas
48 × 33⅞ in (121.9 × 86 cm)

THE RACE

... TO NAIL THAT POP IMAGE

1961 IS A CRITICAL YEAR. IT COMES WITH A RACE TO FIND THE IMAGE THAT ENCAPSULATES POPULAR AMERICAN CULTURE ...

WARHOL IS WORKING ON COMIC BOOKS.

WARHOL VISITS LEO CASTELLI'S GALLERY. IVAN KARP SHOWS HIM ROY LICHTENSTEIN'S PAINTING, 'GIRL WITH BALL'.

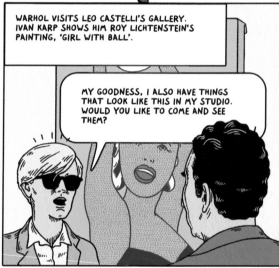

MY GOODNESS, I ALSO HAVE THINGS THAT LOOK LIKE THIS IN MY STUDIO. WOULD YOU LIKE TO COME AND SEE THEM?

THEN LICHTENSTEIN BLOWS UP THE BENDAY DOTS USED IN COMIC PRINT.

LICHTENSTEIN NAILS THE COMIC-BOOK LOOK.

DAMN, HE GOT THERE FIRST!

MEANWHILE, POP ART IS POPPING UP EVERYWHERE.

CLAES OLDENBURG OPENS UP A STORE SELLING PLASTER FOOD. IT'S A GREAT SUCCESS!

DICIEMBRE 1 AL 31

THE STORE BY CLAES OLDENBURG

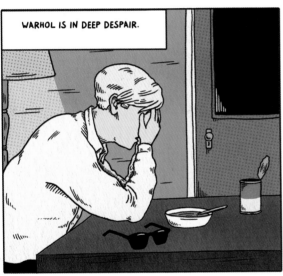

WARHOL IS IN DEEP DESPAIR.

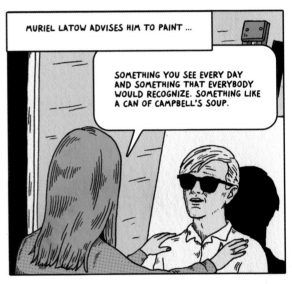

MURIEL LATOW ADVISES HIM TO PAINT ...

SOMETHING YOU SEE EVERY DAY AND SOMETHING THAT EVERYBODY WOULD RECOGNIZE. SOMETHING LIKE A CAN OF CAMPBELL'S SOUP.

WARHOL PAYS LATOW FOR HER IDEA.

OH THAT SOUNDS FABULOUS.

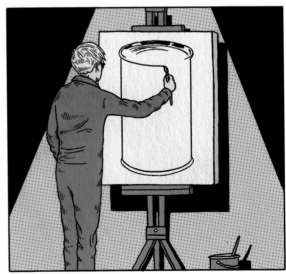

Pop in a brand

In 1962 Warhol painted a Campbell's soup can. Brutally realistic, it looked exactly like the label on the can. Asked later why he chose the subject, Warhol said, 'I used to drink it. I used to have the same lunch every day.' Warhol had found a subject: the American brand. He went on to paint all 32 varieties of the Campbell's soup range, and other iconic brands like Coca-Cola, Brillo pads and even the American dollar.

In her autobiography, Ultra Violet, one of Warhol's hip groupies, gives a funny description of eating out with Warhol: 'Andy doesn't bother to wait for me to make a choice … he orders Coke, cream of chicken soup, peaches in syrup and coffee. By the time I give my order, his food is already in front of him and he has started to eat. "That waitress has no sense of etiquette," I say, not wanting to direct the rebuke at him … I glance from the empty space in front of me to the food before him. "I know all about etiquette," he says huffily. "I illustrated Amy Vanderbilt's *Complete Book of Etiquette* …'

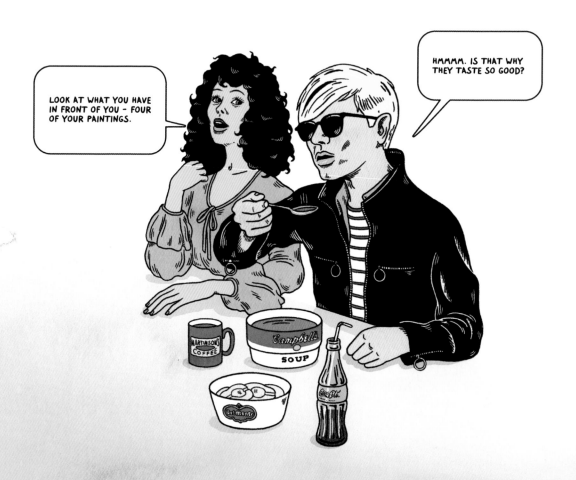

A brand style

The Campbell silkscreens are raw and unedited. There is no 'arty' gesture, like expressive brushwork. Warhol's new attitude was 'leave it as is'. The style outraged the public and the critics. Many were insulted by it. Had he not just copied soup packaging? His treatment is often read as cold and nihilistic. However, by not adorning his subjects, Warhol emphasized a 'natural beauty'.

Warhol credited de Antonio as 'the first person I know of to see commercial art as real art and real art as commercial art, and he made the whole New York art world see it that way too'. Warhol saw the beauty of a Campbell's label, with its simple palette of bold colours, and its classic font. He believed in the brand mythology: the promise of happiness in a bowl of soup or a sugary drink. An immigrant child, he appreciated that this promise was offered democratically to every American citizen. To quote him: 'What's great about this country is that America started the tradition where the richest consumers buy essentially the same things as the poorest. You can be watching TV and see Coca-Cola, and you know that the president drinks Coke, Liz Taylor drinks Coke, and just think, you can drink Coke, too.'

Pop shop

In 1962 Warhol had his first Pop solo show, exhibiting all 32 Campbell's soup cans. In the exhibition he acknowledged the life of the branded product from factory floor to supermarket shelf. Replicating the production line, he made products identical in size (the silkscreens measure 20 by 16 inches) and represented the brand's entire range, from the basic tomato soup to the adventurous cheddar cheese soup. At the exhibition he mimicked a supermarket display, with each silkscreen sitting on its own shelf, and the 32 varieties lined up like well-stacked groceries. Keeping in mind that Warhol grew up in hard times, the display of the full range communicated plenty.

At the core of the Campbell's series is the sensation of sameness: the pictures look the same as each other, and the same as the can. Warhol was the master of repetition, believing that there was something inherently comforting about it. As a child, Warhol would count the stairs up to his front door. He collected antique sets and liked to buy in multiples: supposedly, at Lexington Avenue, one of the rooms was full of unopened bags of candy.

 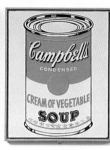 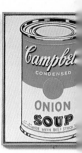

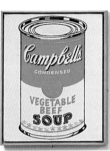 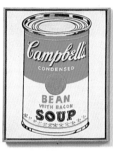 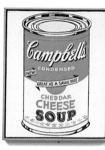

 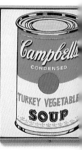

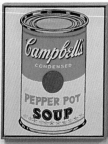 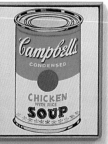 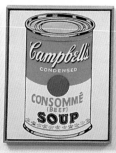 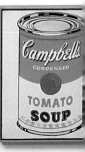

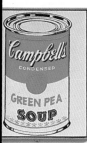
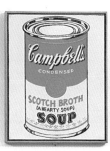
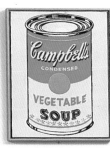

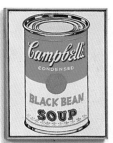
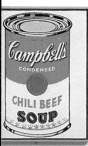
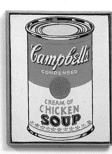
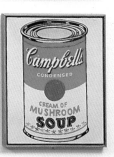
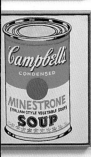
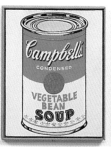

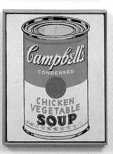
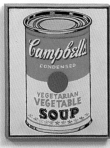
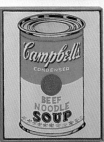

Campbell's Soup Cans
Andy Warhol, 1962

Synthetic polymer paint on thirty-two canvases,
each 20 × 16 in (50.8 × 40.6 cm)
Museum of Modern Art, New York. Gift of Irving Blum; Nelson A. Rockefeller Bequest,
gift of Mr. and Mrs. William A.M. Burden, Abby Aldrich Rockefeller Fund, gift of Nina and
Gordon Bunshaft in honor of Henry Moore, Lillie P. Bliss Bequest, Philip Johnson Fund,
Frances Keech Bequest. Acc. n.: 476.1996.1-32.

Warhol is branded

The move from commercial artist to avant-garde player demanded an image change. For years Salvador Dalí, the Surrealist artist, had entertained New Yorkers with his wild antics and outlandish image. Warhol's lifestyle switch was more complicated since, as cultural theorist Arthur Danto points out, '[he] was seeking entrance into two worlds, the art world and the gay world'. Johns and Rauschenberg, pioneers of the new art and openly gay, were uncomfortable around Warhol. Warhol was 'too swish'. According to writer Fred Lawrence Guiles, 'Despite its outlaw status in 1949–50, the homosexual underworld demanded considerable conformity … you became known for what you did sexually as well as what you wore – leather for sadomasochism, not yet modish but beginning to be taken up by gays … casual masculine attire for closeted cases like Andy and those who chose to look "normal".'

Styling himself on underground fashion, Warhol developed his signature look of dark glasses, leather jacket, high Chelsea boots and jeans. Later he added his spiky, silver hairpiece. The 'swish' lingered in the bad-boy image, reflected in his pet name 'Drella', a mix of Dracula and Cinderella. In the 1960s, Drella became the ultimate in cool; he even had his own rock band. He managed The Velvet Underground, who played in the Factory and dedicated their record *Songs for Drella* to him. According to key band member John Cale, 'Andy Warhol didn't do anything'; he would sit in their studio while they were recording, and gasp: 'Oooh, that's fantastic'. He did design their iconic L.P. sleeve with the printed banana, and the first releases were extra fun: the banana skin was a sticker that could be peeled back to reveal the hidden fruit. With the Velvets, he hosted the 'Exploding Plastic Inevitable', outlandish happenings that featured a manic strobe show and the Velvets performing their music. Sometimes Gerard Malanga would do a whip dance, or Andy would show his avant-garde films.

Writer Steven Shaviro considers that 'Warhol's greatest work of art was himself; he transformed himself into a blank and glamorous – and hence charismatic – figure of appearance.' Warhol perfected the expressionless face, and at interview he played dumb kid, answering with 'gees' and 'hmms'. Andy knew the power of silence: 'I'd prefer to remain a mystery. I never like to give my background.' According to him, 'People are always calling me a mirror.' Mute, and marketed like a well-branded product, he gave nothing away. Indeed, it was not about what was inside the can, it was about the visual spectacle. The Warhol brand signified something special, and also something very cool.

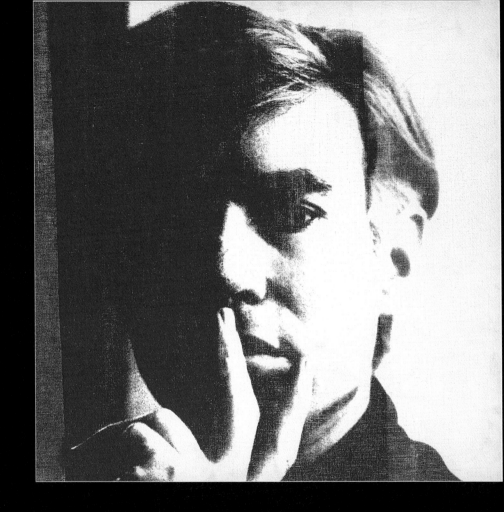

Self-Portrait
Andy Warhol, 1967

Synthetic polymer and silkscreen on canvas
72⅛ × 72⅛ in (183.2 × 183.2 cm)

The Warhol brand

Gerard Malanga, the first assistant at the Silver Factory, styled himself like Warhol, wearing the signature black leather jacket and high Chelsea boots. Andy's other lookalike was Edie Sedgwick. The rich and very beautiful Cambridge girl was like a character from *The Great Gatsby*. 'Bubbly and fresh faced', she dressed in preppy clothes, and her fragile looks were captured by *Vogue*'s high-end fashion photographers. When she became Warhol's muse, to match Andy, she cut her hair short and dyed it silver, and wore mostly black clothes. The Andy brand worked fabulously, and Edie and Andy were the celebrity couple. Everyone wanted them at their party, so much so that people would send cars to pick them up. When they opened Andy's retrospective exhibition at Pennsylvania's Institute of Contemporary Art, they faced a boisterous crowd, chanting their names, desperate to catch a glimpse of them. As Warhol recounts, '[that night] … we were the exhibit.'

Machine art

Warhol famously said, 'I want to be a machine.' He painted his first
Campbell's soup can with a machine-like precision. In 1962 he started
silkscreening, and making art became a machine-like process.
Popular images (brand labels, dollar notes, Hollywood stars) were
photographically transposed onto silkscreen, a template was cut out
and colours were rolled across the template to make a print. Mimicking
a production line, multiple copies were run off, and different-coloured
editions were produced. Warhol was hardly involved in the act.

In the summer of 1963 Warhol hired Gerard Malanga, paying him the
minimum wage, $1.25 an hour. Malanga worked on all stages of the
production: editing photos, cutting out templates and colouring. In time
Warhol hired more workers, or 'assistants', as he called them. They
became part of a slowed-down assembly line. The foreman, Warhol, was
super relaxed; sometimes he had a plan, and sometimes Malanga would
suggest a colour range or an edit. Works rolled out. But from this sluggish
art machine came a lurid, electric art.

The torpid production is somewhat misleading, for there was nothing
accidental about what Warhol did. Like a camera lens, Warhol zoomed
in on his culture. His timing and editing was meticulous. He focused on
the concerns of the day and picked the photos that, to quote from Susan
Sontag's iconic text *On Photography*, 'do not seem to be statements about
the world so much as pieces of it, miniatures of reality', and he highlighted
the poignant details.

Hollywood

Hollywood had captivated Warhol as a child: the stars, the glamour and
the fame. In 1962 he began making silkscreens of America's stars and
pop idols. He didn't meet them, but picked out a publicity shot, enlarged
it and had it coloured up. Unrewarded, the famous sold Andy's art. Andy
knew the power of a celebrity endorsement: 'Good B.O. means good "box
office". You can smell it from a mile away. The more you spell it out, the
bigger the smell, and the bigger the smell, the more B.O. you get.'

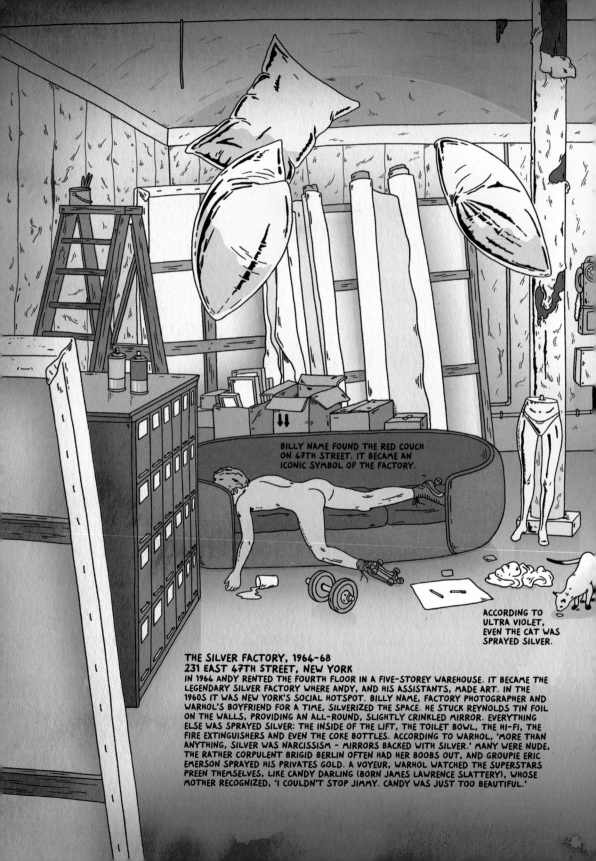

BILLY NAME FOUND THE RED COUCH ON 47TH STREET. IT BECAME AN ICONIC SYMBOL OF THE FACTORY.

ACCORDING TO ULTRA VIOLET, EVEN THE CAT WAS SPRAYED SILVER.

THE SILVER FACTORY, 1964-68
231 EAST 47TH STREET, NEW YORK

IN 1964 ANDY RENTED THE FOURTH FLOOR IN A FIVE-STOREY WAREHOUSE. IT BECAME THE LEGENDARY SILVER FACTORY WHERE ANDY, AND HIS ASSISTANTS, MADE ART. IN THE 1960S IT WAS NEW YORK'S SOCIAL HOTSPOT. BILLY NAME, FACTORY PHOTOGRAPHER AND WARHOL'S BOYFRIEND FOR A TIME, SILVERIZED THE SPACE. HE STUCK REYNOLDS TIN FOIL ON THE WALLS, PROVIDING AN ALL-ROUND, SLIGHTLY CRINKLED MIRROR. EVERYTHING ELSE WAS SPRAYED SILVER: THE INSIDE OF THE LIFT, THE TOILET BOWL, THE HI-FI, THE FIRE EXTINGUISHERS AND EVEN THE COKE BOTTLES. ACCORDING TO WARHOL, 'MORE THAN ANYTHING, SILVER WAS NARCISSISM - MIRRORS BACKED WITH SILVER.' MANY WERE NUDE, THE RATHER CORPULENT BRIGID BERLIN OFTEN HAD HER BOOBS OUT, AND GROUPIE ERIC EMERSON SPRAYED HIS PRIVATES GOLD. A VOYEUR, WARHOL WATCHED THE SUPERSTARS PREEN THEMSELVES, LIKE CANDY DARLING (BORN JAMES LAWRENCE SLATTERY), WHOSE MOTHER RECOGNIZED, 'I COULDN'T STOP JIMMY. CANDY WAS JUST TOO BEAUTIFUL.'

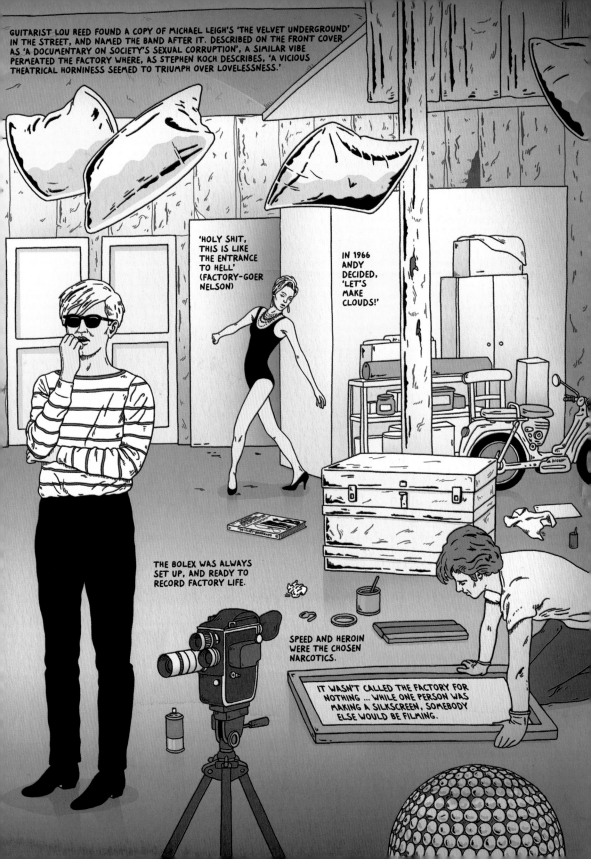

Framing the Marilyn moment

On 5 August 1962, Marilyn Monroe, the film star and idol, died of a drug overdose. Warhol sensed a good story. According to groupie Ultra Violet, Warhol always knew that death was a good seller. She remembers telling him, 'You know how Madison Avenue uses death symbols to lure people.' She reckoned that '[Warhol] was the master'. Aware that 'timing is all', the very next day Warhol phoned Marilyn's agency and bought a publicity still of her. Multiple editions were run out from 1962 to 1968 in an array of fantastic Pop colours: brash red, neon blue, lurid green, and even silver and gold. The Marilyn portraits sold for thousands, later millions.

Living in the detail

While death is central to the Marilyn portraits, still the essence of the living Marilyn is captured. Actress Arlene Dahl describes the star's magnetism: 'It was magical, really. I've never seen anyone stop a room like that … People just wanted to stand near her, smell her fragrance, breathe the same air.' The publicity shot is blown up, creating a face-to-face encounter with the 'real' Marilyn, and that alluring aura. Warhol highlights her features with brilliant colour: a brassy blonde for her hair, scarlet for her lips, and a turquoise swirl of eyeshadow. The amped, gaudy hues reflect the glitz of Hollywood.

Roland Barthes, the philosopher and cultural theorist, argues that a great photograph includes some detail that catches one off-guard. Barthes calls it the photograph's 'punctum', and describes it as 'that accident which pricks me (but also bruises me)'. The poignant detail here is Marilyn's mouth. She smiles for the camera, but her mouth is tense; she bites down, and the edges of her teeth touch. The whisper of strain breaks the illusion of 'effortless' glamour. Somehow we sense the tragic Marilyn, who struggled with drug and alcohol addiction, and a series of unhappy relationships. Art critic Michael Fried felt Warhol was at his best in the Marilyn portraits, since they captured 'what is truly human and pathetic in one of the exemplary myths of our time'.

In *Marilyn Monroe's Lips*, Warhol picks out just the lips, and repeats the image serially. Perhaps Warhol is alluding to that infamous performance (19 May 1962), a few months before her death, when Marilyn blew a kiss to President Kennedy after singing 'Happy Birthday Mr President'. It was widely known that Monroe and the president had had an affair; the Secret Service followed their weekend together in Palm Springs. Warhol said that in time everybody would be famous for 15 minutes. By serially repeating her lips across a canvas, Warhol extends Marilyn's 15 minutes, each image giving her another moment.

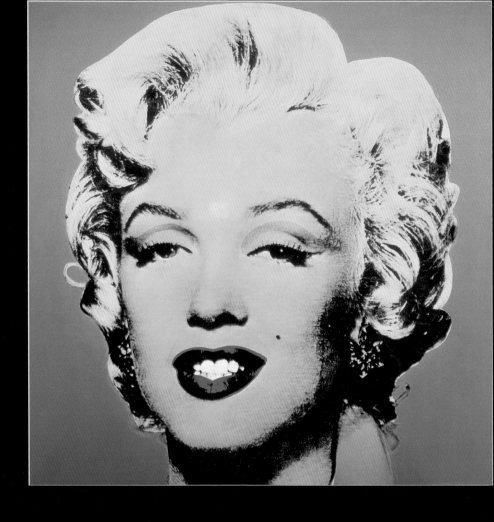

Marilyn
Andy Warhol, 1964

Synthetic polymer paint and silkscreen ink on canvas
40 × 40 in (101.6 × 101.6 cm)

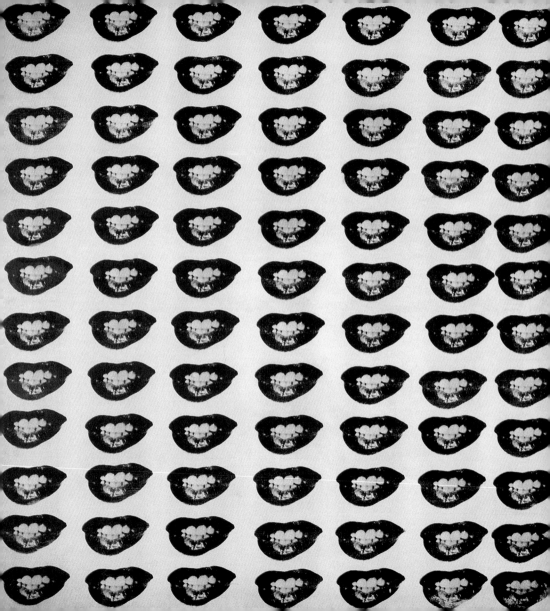

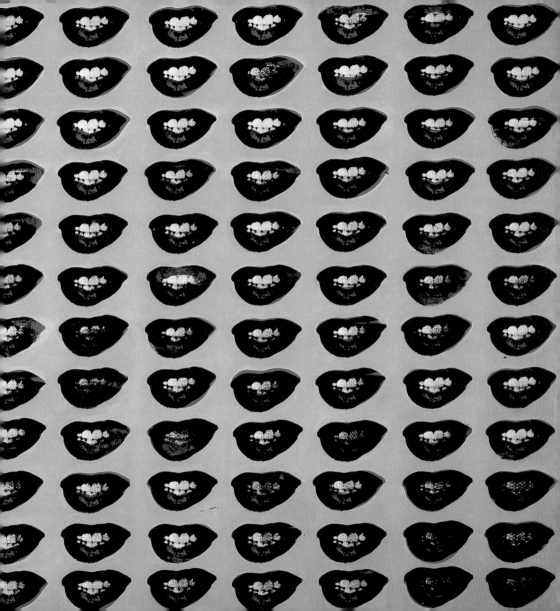

Bullet Marilyns

Four Marilyn silkscreens feature bullet holes through the idol's forehead. How this came about is related by one of Andy's groupies: 'One day, Dorothy arrived, dressed in leather, with several friends in leather, and a Great Dane in his natural leather pelt. She peeled off her long leather gloves, pulled out her pistol, aimed at Warhol. Then at the last split second she shifted her aim to the stack of Marilyn Monroe portraits against the wall and fired.'

'Dorothy' was Dorothy Podber. When she left, Warhol turned to Billy Name, and said, 'Please don't let Dorothy do that again.' Once described as a 'marvellous, evil woman', Dorothy had a serious drug problem, and for a while she ran an illegal abortion clinic. She was banned from the Factory. The incident was a foreboding warning – four years later Factory-goer and feminist Valerie Solanas would enter the Factory and shoot Warhol in the chest. Warhol decided that the damaged canvases should not be repaired. Sold as 'The Shot Marilyns', they raised the highest prices of all the Marilyn portraits.

'Death and Disaster' series

The 'Death and Disaster' series is a chilling counterpoint to the early Pop images that optimistically embrace everything American. Henry Geldzahler, a curator at the Metropolitan Museum of Art, had been working on Warhol for a while, and apparently told him: 'That's enough affirmation of life … enough affirmation of soup and Coke bottles. Maybe everything isn't so fabulous in America. It's time for some death.' While tragedy is the subtext of the Marilyn portraits, Marilyn is very much alive, and looking fantastic. Generally, the portrait is received as an iconic pin-up of a great American beauty.

The 'Death and Disaster' images are uncompromising and gruelling: in *Suicide* a figure jumps from a building, and in *Car Crash* a body, covered in blood, lies dead on the ground. Every work is based on a press photo, which is then enlarged and coloured. According to Warhol, Geldzahler 'gave him the idea' for his first one, *129 Die in Jet*. Over lunch, Geldzahler pointed to the front page of the *New York Mirror*, which reported a plane crash, and suggested that it could make a good subject. Warhol liked the idea. *129 Die in Jet*, 1963, is a crop of the front page. In everyday life we would skim past the 129 victims, but Warhol gives them their 15 minutes of fame.

Often the death or disaster scene is serially repeated across the canvas, like Marilyn's lips, mimicking the way we are bombarded with images in everyday life. Warhol was acutely aware that the TV generation had become numbed to disaster and had little compassion. As he said, 'It's just that people go by and it doesn't really matter to them that someone unknown was killed.' In Warhol's hands repetition is probing. It forces confrontation. It makes the viewer look again, and again, and again … until they finally get it, experiencing horror and tragedy anew.

PLEASE DON'T LET DOROTHY DO THAT AGAIN.

The electric chair

Some of the images in the 'Death and Disaster' series deal with contentious or political deaths. Warhol shows Jackie grieving after the assassination of John F. Kennedy. He also represented the setting of a public execution. In the 1960s the death penalty was a highly topical issue. On 15 August 1963, Eddie Lee Mays was executed by electric chair for murder and robbery. It was the last execution in New York. As with Marilyn, Warhol the entrepreneur tapped into the zeitgeist, seized the subject of the day, framed it and sold it.

Warhol presented himself as the unfeeling machine, but *Little Electric Chair* is a highly emotional scene; as Ultra Violet said, 'It hurts.' Its charge is connected to Warhol's non-involvement, and his refusal to embellish or comment on the event. Re-presenting an old photo, Warhol functions as a mirror to society. Carl Jung describes the potency of this powerful archetype: 'Whoever looks into the mirror of the water will see first of all his own face. Whoever goes to himself risks a confrontation with himself. The mirror does not flatter, it faithfully shows whatever looks into it; namely, the face we never show to the world because we cover it with the persona, the mask of the actor. But the mirror lies behind the mask and shows the true face.' Dread is built into the mirror experience. One is reminded of that fearful moment in the fairy-tale *Snow White* when the Wicked Witch chants, 'Magic mirror in my hand, who is the fairest in the land?' The Warhol mirror is merciless. Humanity faces its true ugliness.

We are shown into the execution room. The electric chair sits in a chilling, empty chamber. There is no sign of anything living. There are no people, no noises and no movements. We are faced with a paralysing inertia, and the absence of life starkly communicates loss, and the life that has been or will be taken. Confronted by the actual room, the debates and arguments are lost.

Silence

Returning to philosopher Roland Barthes, his idea was that a great photograph possesses a detail that 'takes the spectator outside its frame and it is there that I animate this photograph and it animates me.' In *Little Electric Chair* that detail is the sign that reads SILENCE. The word seems so inappropriate in a scene where a man dies, and other men are forced to watch him suffer. The word SILENCE 'pierces'. One senses the noise and sound that no one wants to hear: cries of horror, guilt and pain.

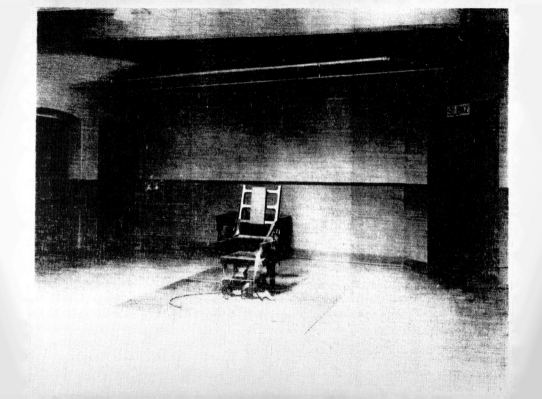

GERRARD MALANGA AND BILLY NAME WERE CLOSEST TO WARHOL: NAME MADE THE BACK TOILET INTO HIS DARK ROOM AND SLEPT AT THE FACTORY; HE BROUGHT ORDER TO THE SCENE, AND KEPT EVERYONE IN CHECK.

BEYOND THE SUPERSTARS LAY THE CIRCLE OF INFLUENCE: THE GALLERY OWNERS, CRITICS AND PATRONS ON WHOM WARHOL DEPENDED. AND THEN OCCASIONALLY A CELEBRITY DROPPED BY.

VIVA

ALLEN GINSBERG

INGRID SUPERSTAR

JAMES ROSENQUIST

BILLY NAME

TRUMAN CAPOTE

JACK KEROUAC

TAYLOR MEAD

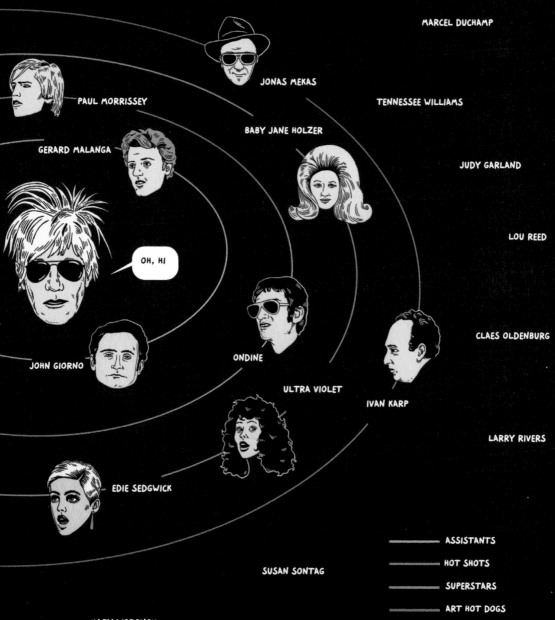

The instant portrait

A Polaroid camera that usually hung round Warhol's neck allowed him to snap the scene at the Silver Factory as it unfolded. Robert Scull, a New York taxi baron, commissioned Warhol to make a portrait of his wife, Ethel. Ethel was the perfect subject for a Pop portrait. She was beautiful, and 'My life had all the glamour and glitter of Hollywood starlet's'.

The traditional oil portrait involves a long, deliberative process that can take months: there are lengthy sittings for the client, the artist makes numerous studies and painting with oil is slow. Warhol fast-forwarded the process. Without an appointment, he turned up at the Scull home with $100 in coins, and rushed Ethel downtown to some photo booths in a pinball arcade in Times Square. Initially Ethel protested: 'In those things? My God. I'll look terrible!' The two of them had fun. Ethel ran between booths, and Andy would emerge from behind the curtain and tickle her. Andy collected 24 sheets of four-frame instants. Later he chose the best shots, blew them up and made a 36-frame portrait.

Ethel said, 'What I liked about it mostly was that it was a portrait of being alive.' Again it is key that Warhol uses photography. This is not a representation of Ethel; the photomat is snapping involuntarily, recording life as it appears before it, catching Ethel in the act of living: in one frame she is laughing, in another she is adjusting her glasses, and in many she is posing. The work has real energy. The colours almost seem thrown together, with zesty greens set against deep reds and resonant blues. The randomness is life. In some frames Ethel is cut off, presumably as she jumps in or out of the booth. Warhol plays with the serial form. Dynamic patterns fight for attention: the eye may follow the yellow frames, or trace the pattern of blue stills. Two frames are based on the same still – Ethel throws back her head with her mouth wide open – and the repetition creates an eerie echo that contrasts with the sporadic and exuberant energy.

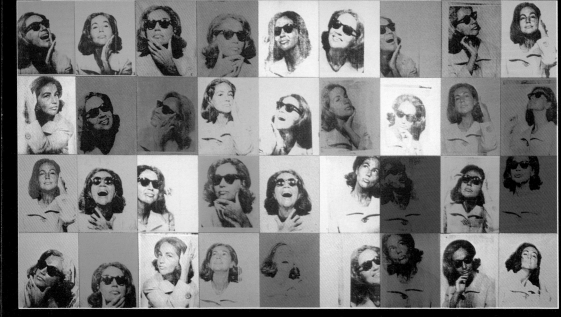

Ethel Scull Thirty-Six Times
Andy Warhol, 1963

Synthetic polymer paint and silkscreen ink on canvas
79¾ × 143 in (2.02 × 3.63 m)

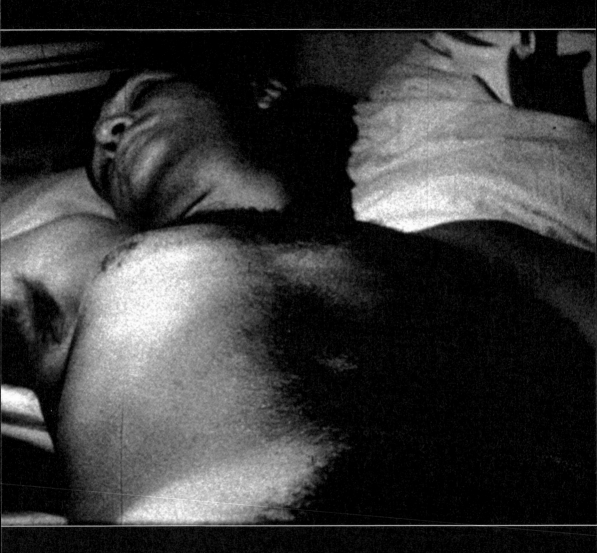

Sleep
Andy Warhol, 1963

16 mm film, b/w, silent, 5 hours and 21 minutes at 16 fps

Warhol's films

In 1963 Warhol started making films. *Sleep* is a 5-hour-and-21-minute film of his boyfriend, John Giorno, sleeping on the red sofa that Billy Name had dragged into the Factory. In his usual deadpan way, Warhol said that he made the film because Giorno 'slept a lot'. Sleep is very boring to watch. Everyone knew it was boring, but, as Warhol reflects, 'Sometimes I like to be bored, and sometimes I don't – it depends what kind of mood I'm in.' Jonas Mekas, director at the Film-Makers' Cooperative, tied Warhol to his seat to make sure he watched the entire film. Halfway through, Mekas went to check on him, and found only the rope that he had tied him up with. Warhol had wriggled free.

The films look very different to the garish Pop silkscreens. However, they share an outlook: like the Campbell's soup cans, *Sleep* is about the poetry of the everyday. Warhol uses time frames to hold our attention. While his serial silkscreens repeat the same moment, his films deliver extended periods of time. *Sleep* is incredibly long. Slowing down the camera speed from 24 to 16 frames a second, Warhol disrupts the cinematic flow, which carries us along, creating anxiety and throwing us off-guard. Is John breathing OK? Why does he move so slowly? There is something we are seeing that we cannot explain, and this pulls us in. Andy achieves his goal: we are thinking about something ordinary.

Jonas Mekas talks about the 'burning, intensified reality' of Warhol's films. The pace of the camera acts like a temporal close-up: we observe minutial changes, which usually go undetected by the human eye. Sometimes Warhol would just let the camera roll, and record life slowly unfolding; of course, as he admits, 'Factory life was pretty extraordinary'. In December 1967, Warhol sat with friends and watched 25 hours of film that they had shot over the last year. Nostalgically Warhol reflects how 'Seeing it all together that night somehow made it more real to me … than it had been when it was happening, to see Edie and Ondine huddled together on a windy deserted beach on a gray day, with only the sound of the camera, and their voices blown away over the sand dunes while they tried to light their cigarettes … I knew we'd never screen it in this long way again, so it was like life, our lives, flashing in front of us … it would just go by once and we'd never see it again.'

Out of the frame: Silver Clouds

In 1966 Leo Castelli offered Warhol an exhibition. Warhol had always wanted to be represented by Castelli, so it was an important moment for him. He created two interiors: one room was wallpapered with Day-Glo cows, and the other was filled with free-floating silver balloons.

There is an innocent, childlike quality to the clouds: the pillows collide with each other and bump into visitors. To create them, Warhol consulted with engineer Billy Klüver, who recommended the new material, Scotchpak. Klüver also calculated the necessary quantities of helium and oxygen for the pillows to float in mid-air. The idea may have come from a tea party with Salvador Dalí. A year before the Castelli exhibit, Warhol had visited Dalí at his hotel suite, and seen silver balloons bobbing round the room. When he left, he rushed off and bought some, and took them back to the Factory. Of course, Andy's *Silver Clouds* were bigger and better.

There is an inherent fragility about the installation: some balloons burst, all of them eventually deflated. The scene at the Factory was another silver bubble waiting to burst. For years the silent Warhol had held everyone's attention. However, by the mid 1960s, as one reporter tells, 'The waspish, silvery-haired Maharishi was in trouble, deep trouble. His world suddenly stopped caring, stopped knowing.'

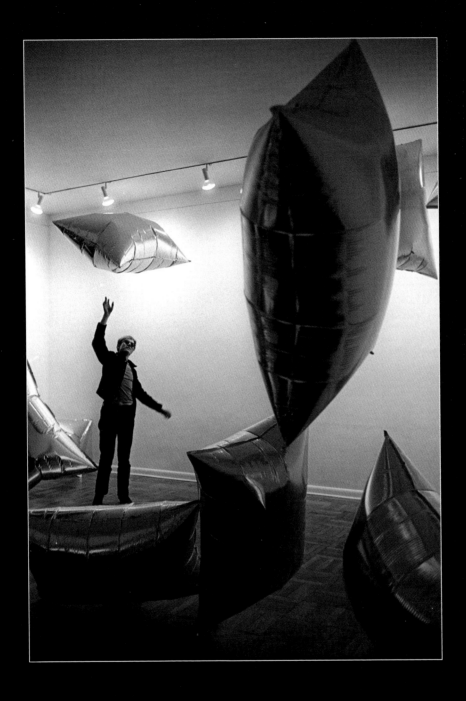

Andy Warhol with Silver Clouds installation
Leo Castelli Gallery, New York, 1966

The Pied Piper

For the sensitive souls, the scene at the Factory was like the tale of the Pied Piper: mesmerized by Warhol, they fell around him. In 1967 Gerard Malanga took a trip to Italy, and never returned. During his time as Factory foreman, Malanga had been paid the minimum wage out of Warhol's million-dollar estate. In Italy, Malanga sold fake Warhols. Meanwhile, Billy Name isolated himself more and more, and rarely emerged from the darkroom.

For a short time Edie Sedgwick had been the goddess of the silver world, but she had become paranoid and miserable. To quote her: 'Everything I did was really underneath, I guess, motivated by psychological disturbances. I'd made a mask out of my face because I didn't realize I was quite beautiful, God blessed me so. I practically destroyed it. I had to wear heavy black eyelashes like bat wings, and dark lines under my eyes, and cut all my hair off, my long, dark hair. Cut it off and strip it silver and blond ... I was a good target for the scene; I blossomed into a healthy young drug addict.'

Many blame Warhol for Edie's demise. Warhol was attracted to vulnerable characters, as he says, 'A girl always looked more beautiful and fragile when she was about to have a nervous breakdown.' He partied hard with Edie, but when she fell apart he never intervened, or cared for her. Edie left the Factory a lost soul. She died of a drug overdose in 1971.

Vacating the Silver Factory

At the end of 1967 the Factory got an eviction order. The building was falling down. Film director Paul Morrissey admits: 'Actually, it was a good thing. The silver spray paint kept crumbling off and deteriorating into silver dust. It got sort of bad to breathe after a bit, and it was hard to clean.' In 1968 the Factory was vacated, and the famous sofa was brought down. Somehow, in the process of moving, the sofa was lost. According to Morrissey, it was loaded onto the removals truck, and in the night the truck was stolen.

It was the end of an era. When the Factory relocated to a loft in Union Square, the decor changed and the atmosphere was very different, as Warhol describes: 'Everyone could sort of sense that the move downtown was more than just a change of place – for one thing, the Silver Period was definitely over, we were into white now. Also, the new Factory was definitely not a place where the old insanity could go on. Even though the "screening room" had couches and a stereo and a TV and was clearly for lounging around, the big desks up front as you came in off the elevator gave people the hint that there was something going on in the way of business, that it wasn't all just hanging around anymore.'

Paul Morrissey and Fred Hughes ran the new scene. Hughes, a virulent social climber, despised the old groupies, and Andy did not want a rebellious entourage around him anymore. Only the beautiful superstars (Viva, Ultra Violet, Nico) were welcome. As Warhol distanced himself, resentments grew. People felt cast aside. Feminist and Factory-goer Valerie Solanas was exasperated: according to her, talking to Andy was like talking to a chair.

Warhol is shot

On Monday 3 June, 1968, at 4.15 pm, Valerie Solanas walked into the Factory, pulled out a .32 calibre gun, and fired at Warhol. Mayhem followed, and a weeping Billy Name held Warhol as they waited over 20 minutes for the ambulance. Meanwhile superstar Viva thought it was a staged joke, and booked herself a trim at the hairdressers. At Columbus Hospital, at 4.51 pm, Warhol was pronounced clinically dead. However, on hearing that their 'dead man' was the legendary Warhol, medics rushed to revive him, and then performed life-saving surgery.

The motive is SCUM

Years before the shooting the playwright Arthur Miller had met Solanas at the Chelsea hotel in New York. His view was that: 'She's dangerous. She's going to wind up killing somebody.' Solanas was author of a manifesto called SCUM: the Society for Cutting Up Men. She was the sole member. People had warned Warhol about Solanas. When Ultra Violet told Warhol, 'You might be a target for her', Warhol had laughed. Solanas was angry with Warhol. She had written a play. She wanted feedback, and she wanted the script back. Warhol did not engage, and he did not know where her script was.

After the shooting Warhol was on high alert: 'I wasn't afraid before. And having been dead once, I shouldn't feel fear. But I am afraid. I don't understand why.' Billy Name missed the old Andy: 'It was the cardboard Andy, not the Andy I could love and play with.' In 1970 he pinned a note to the darkroom door and left the scene. Many felt that Andy lost his creative direction. As one Factory girl put it: 'His death wish fuels a fire that blazes into paintings, films, originality, energy, art. But now that the acrid taste of death fills his own mouth, the game is up … his inspiration looses.'

In the 1960s Warhol had been like a camera lens on high focus, zooming in on his culture, capturing the day's concerns and distilling the mood. But in the 1970s the lens was no longer held taut, and Warhol was distracted. His mother had become very frail. In 1970 she moved back to Pittsburgh and was looked after in a care home. Two years later she died. Warhol did not go to her funeral. He never accepted her death: if someone asked after Julia, he told them that she was shopping at Bloomingdale's.

ANDY I AM NOT HERE ANYMORE.
BUT I AM FINE
LOVE
BILLY

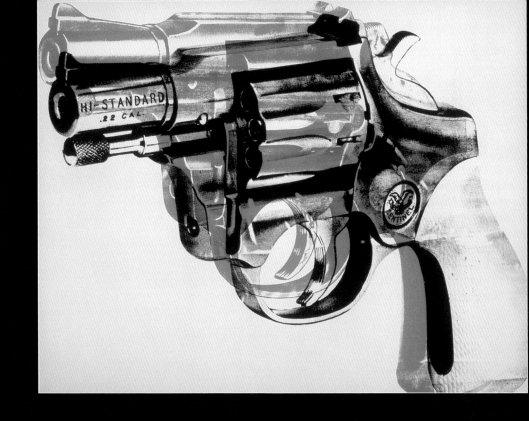

Gun
Andy Warhol, c. 1981–82

Narcissistic 1970s

The change in Warhol mirrored a shift in culture, as the American sociologist Christopher Lasch explains: 'After the political turmoil of the sixties, Americans have retreated to purely personal preoccupations … getting in touch with their feelings, eating health food … jogging, learning how to "relate", overcoming "the fear of pleasure" … Indeed Americans seem to wish to forget not only the sixties, the riots, the new left, the disruptions on college campuses, Vietnam, Watergate and the Nixon presidency, but their entire collective past.' Warhol took up all the trends that Lasch mentions.

Parties, parties, parties, all winter, all spring, all night

In the 1970s Andy could make four parties in one night. The scene was very different to the Silver Factory days; according to Bob Colacello, 'Fred [Hughes] made Andy something he never was before: exclusive.' Warhol's new elite set included Mick and Bianca Jagger, Liza Minnelli, Truman Capote, Diane and Egon von Fürstenberg, Diana Ross, Calvin Klein, Diana Vreeland and Oscar de la Renta. It was the age of disco, and the ultimate celeb venue was Studio 54, where Andy hung out with the 'young, beautiful and loaded'. Doorman Marc Benecke was told to mix a 'perfect salad every night'. Guests needed to complement the 'vibe', if you did not look right you were tossed out, even if you were a celeb.

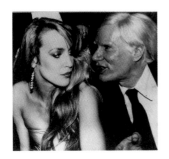

Andy Warhol talking to
model Jerry Hall at club
Studio 54.

The celeb mag: *Interview*

In 1969 John Wilcock and Warhol set up *Interview*. One of the first
celebrity magazines, it became an extension of the party scene.
Colacello describes '[the] intense symbiotic relationship between
magazine and club [Studio 54] … each feeding the other's glamour,
elitism and cachet'. Each month Andy put one of his friends on the
front cover.

Warhol's formula for the magazine was simple: 'The interviews can be
funny but the pictures can't.' Warhol trusted artist Richard Bernstein
with the job of making everyone look beautiful. Bernstein airbrushed
over people's imperfections, and embellished features with pencil and
pastel; as Paloma Picasso recognized, '[Bernstein] portrays stars … He
celebrates their faces, he gives them larger-than-fiction size. He puts wit
into the beauties, fantasy into the rich, depth into the glamorous and adds
instant patina to newcomers.'

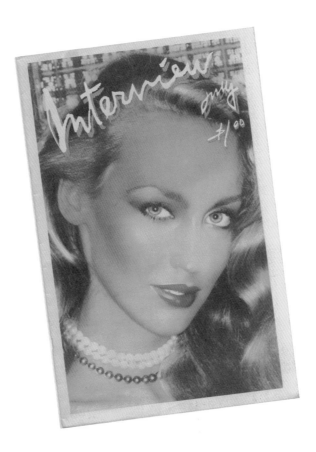

Interview magazine, 12 July 1978,
featuring a painting of Jerry Hall
by Richard Bernstein.

Andy Warhol Enterprises

In the later years Warhol developed the concept of Business Art. According to him, 'Business Art is the step that comes after Art. I started as a commercial artist, and I want to finish as a business artist … Being good in Business is the most fascinating kind of art.' In 1974 he moved his studio into a commercial building on 860 Broadway. Reflecting his corporate ambitions, he referred to the new space as the Office, rather than the Factory. It housed Andy Warhol Enterprises: from a back room Bob Colacello, writer and editor, ran the celebrity magazine *Interview*, while Fred Hughes, professional networker, worked front of house, developing the portrait business.

The clutter that filled the Factory was stored away. Jed Johnson, Warhol's boyfriend at the time, designed the space like a luxury brand. The reception room was kept bare: a few quality pieces – an art-deco table of hammered brass and two slate tables – were carefully placed. The open 'white space' was extravagant. Smart boys in suits busied themselves and took calls on white telephones, while Warhol worked from his private pod.

LIFE AT THE OFFICE.

(FROM LEFT TO RIGHT)

FRED HUGHES
DIANE VON FÜRSTENBERG
BOB COLACELLO
'THE CLIENT'
PAT HACKETT
JED JOHNSON
ANDY WARHOL

Lunches at the Office

Guests invited to the Office were on their best behaviour, as writer Stephen Koch tells: 'As for the atmosphere of freedom in this new place, there is no such atmosphere. Light a cigarette and you'll fret about the ashes.' Security was a top priority. Everyone had to check in with the receptionist, and a high-end security system, with closed-circuit TVs, was installed. Andy even asked the landlord to hire an armed guard for the lobby.

Business lunches were held in the dining room for potential portrait clients and corporate companies that might buy ad space in *Interview*. Vincent Fremont, the vice president of Warhol Enterprises, reminisces: 'I often think about all the lunches which centered around the person who was to have a portrait done. First there was the Brownies box lunches at 33 Union Square West, then Balducci's lunches at 860 Broadway … I miss the hustle and the flurry of preparation, who else was going to be invited to lunch, the gossip told at the table, Andy's tape recorder desperately trying to get it all. Fred would be entertaining this one and that one; Bob Colacello would be telling stories about the night before or recanting some other humorous tale.'

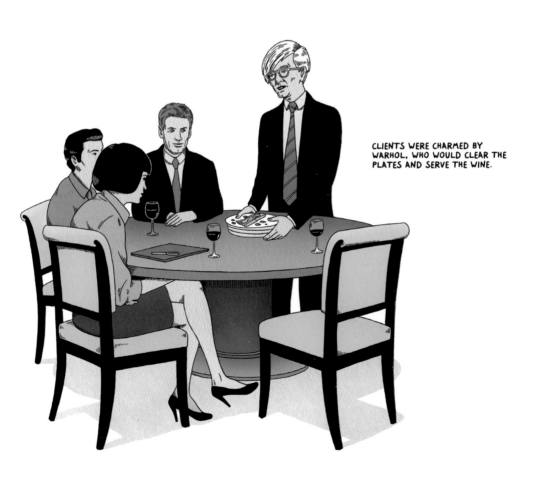

CLIENTS WERE CHARMED BY WARHOL, WHO WOULD CLEAR THE PLATES AND SERVE THE WINE.

The portrait business

The narcissistic 1970s was the perfect time to make portraits: the rich, the beautiful and the fashionable wanted to be immortalized. Taking the role of court painter to his elite set, Warhol managed to resurrect, to quote art historian Robert Rosenblum, 'from near extinction … grand style portraiture'. Fred Hughes and Bob Colacello worked hard to establish a thriving portrait business. Every friend was a potential portrait client. Every party was a business opportunity, as Colacello tells: 'We worked the room for Andy. We popped the question for Andy. We even ate the food for Andy, who passed things he couldn't eat onto our plates … I whispered jokes in their ears, and Andy said "Oh, hi, gee".'

This time Warhol performed the celebrity makeover. Of course, that was kept hush hush. The late portraiture is very different from his early work. Liza Minnelli's portrait does not have the charge, or the nuanced tension of the Marilyn portrait, despite the fact that Minnelli had a similar tumultuous life (like Marilyn, she had a serious drug problem and a chain of broken marriages). The struggles are glossed over. It is all about the glamour. The artificial lighting and the disco palette captures the essence of the all-night party. Minnelli's large eyes and black helmet of hair are highlighted, while her cupid lips, artfully lined with orange and touched with gloss, float like an icon of perfection in white space. The disembodied feature is like a logo, fitting for the new Business artist.

Stars could be extremely demanding. Liz Taylor, a good friend of Warhol, was especially tricky. Andy would turn up to take her photo and she would send him away, always with the same excuse: she looked 'too puffy'. His patience, however, was rewarded. Bob Colacello notes that in the early 1970s a single frame sold for $5,000, and by 1980 the price tag had soared to $20,000. Warhol had a further trick: clients were encouraged to buy multiple frames, like the 36-frame Ethel Scull portrait.

Liza Minnelli
Andy Warhol, 1978

Detail of the right of two panels
Synthetic polymer paint and silkscreen ink on canvas
40 × 40 in (101.6 × 101.6 cm) each panel

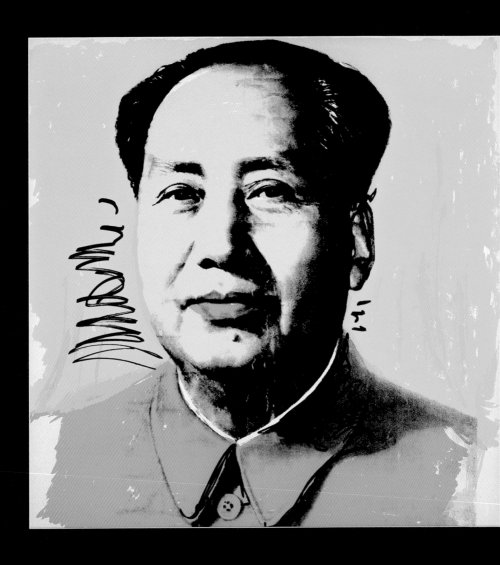

Mao
Andy Warhol, 1972

Screenprint on white paper
36 × 36 in (91.44 × 91.44 cm)

Andy's Mao

Some projects from the late period show Warhol back on high focus. His portrait of the Chinese communist leader Mao Zedong, for example, is a tense, social document. When Warhol talked about the project, he blithely slipped past the looming issues, and chattered amusingly around the subject. To quote him: 'I've been reading so much about China. They're so nutty. They don't believe in creativity. The only picture they have is of Mao Zedong. It's great. It looks like a silkscreen.' However, back on form, his timing and strategy were unnerving.

After the hostility of the Cold War years, America and China were cautiously moving towards a friendlier relationship. In February 1972 President Nixon made his landmark trip to China, which opened communication between East and West. Warhol picked this highly sensitive, political moment to produce a portrait of the feared totalitarian leader. He used the state photo of Mao, illustrated in the ruler's Little Red Book (with a print run of over 2.2 billion copies during the Revolution), and the face that presided over Tiananmen Square.

The monumental scale of the portrait conveys the enormity of Mao: his presence and power in communist China. However, beyond this, Warhol is pretty irreverent. This is Mao 'coloured in': a sunny yellow and tender russet warm up the austere leader. His 'peachy' lips, highlighted eyes, and the decorative scribbles around his face have the flavour of a high-end fashion shot. The frivolity is fraught. During the Cultural Revolution in the late 1960s, Chinese artists and intellectuals were punished for their meaningless pursuits, given hard labour, and re-educated. In China Warhol would have been imprisoned. However, for the Western viewer, Warhol took the threat out of Mao. Mao becomes a Pop icon, and another piece of capitalist merchandise.

In 1982 Warhol visited China. Photographer Christopher Makos captured Andy at Tiananmen Square, looking like an ordinary tourist with backpack, bum belt and camera. If Warhol demystified the mythology surrounding Mao, China did the same to Warhol. Outside of the Big Apple, in the East, Warhol was unknown. A nobody. His Pop perspective on the 5,000-year-old culture is painful: 'I went to see the Great Wall. You know, you read about it for years. And actually it was great. It was really, really, really great.'

A private world for Warhol

In 1974 Warhol had a big clear-out. An insatiable shopper, he had turned his five-storey house at Lexington Avenue into a grand junkyard: artefacts and bargain buys (often in their paper bags) were stacked up everywhere, and Warhol was living out of the kitchen and his bedroom. Instead of selling Lexington Avenue, he simply moved out and left the bric-a-brac behind. His new home on East 66th Street oozed luxury and glamour. Jed Johnson, Andy's boyfriend who had styled the Office, turned his attentions to Warhol's domestic world. According to Jed's twin brother, 'Jed's design education began by sorting Andy's things.' He picked out Warhol's finest pieces – the Oriental carpets, primitive paintings and art-deco furniture – and placed everything in simple, classical interiors.

Warhol had always liked to hang out at home, eating candy, watching telly and talking to his friends on the phone. 66th was a sealed sanctuary. According to Vincent Fremont, 'Very few people ever got into the house.' Warhol lived with Jed and his two dachshunds. It was a spiritual haven; an old photograph of Andy's bedroom shows religious icons and devotional texts stacked up around his bed.

Warhol talks

In 1975 Warhol published *The Philosophy of Andy Warhol: From A to B and Back Again*. After years of 'gees' and 'hmms' at interview, and with a lot of help from editor Pat Hackett, Andy talked. Starting with 'Love' and ending with 'Underwear Power', he chats away on a range of subjects. Sometimes the book makes for an agonizing read as Andy falls somewhere between Mr. Bean and Fyodor Dostoyevsky's *Idiot*. The book opens with him looking in the mirror and finding a new pimple, and his comic self-annihilation continues: 'So I look awful and I wear the wrong pants and wrong shoes and I come at the wrong time with the wrong friends, and I say the wrong things and I talk to the wrong person …'. However, playing the true Fool, Warhol's witty musings are insightful. Talking about how people occupy space, he nails different characters, and amusingly pinpoints behaviour traits.

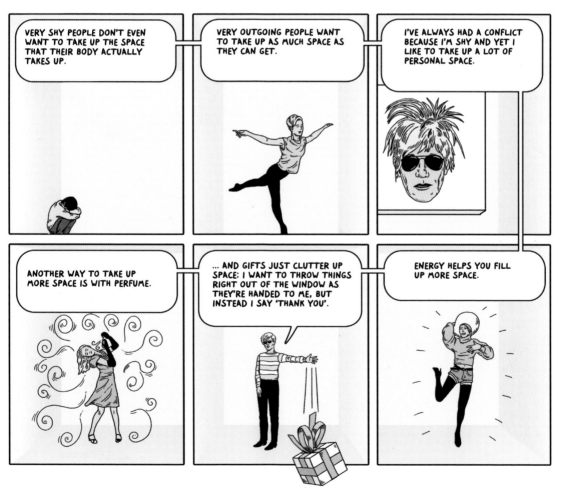

The Time Capsules

In 1974 Warhol started making Time Capsules. He said that the idea came to him during his big clear-out, when he packed all his stuff into cardboard boxes. Afterwards he bought in more boxes, and started filing away his bits and bobs. At the Office there were always a few boxes on the go. A typical capsule holds about 200 items, and there are some odd things – a diary of John Lennon, Warhol's greasy wigs (which, according to one archivist, resemble roadkill), a 2,000-year-old mummified foot, and even a half-eaten piece of pizza. When a box was full it was sealed with masking tape, dated and put into storage. Between 1974 and 1987 Warhol filled 612 capsules, which are now held at the Andy Warhol Museum in Pittsburgh.

Warhol thought of the time capsules as a work of art, and intended to sell them in a gallery. In the museum archives, the modular boxes line up along industrial metal shelving, displaying a brutal minimalist aesthetic. Inside the austere-looking boxes lies a very complicated man. We uncover the neurotic Andy: one box contains empty bottles of echinacea and valium, an acne treatment and a thermometer. Box 44 unveils Warhol's media mind. There are film shots, newspapers with tragic headlines (material for the 'Death and Disaster' series), gallery invitations (including a fantastic Dubuffet promotion), fashion photos, and some of his own commercial work. There are stories (mostly camp ones), and letters to read, and the distinctive graphics and fashion styles reflect their time.

Viewing the multitude of things in one box highlights the scale of the collection. It is an overwhelming memento and, although art historians have sifted through many of the capsules, over 25 years after his death some boxes still remain sealed. Psychotherapists regard obsessive collecting as a form of self-therapy, a soothing impulse that counters feelings of helplessness, abandonment and isolation. Warhol's anxiety is profound. Fearing oblivion, an insatiable collector, he saves the daily debris of his life.

In 1890, the psychologist William James made the valid point that the collector comes in many forms. What kind of collector was Warhol? In Lexington Avenue, Warhol was the hoarder. Interestingly, the time capsules show a shift in his collecting sensibility. Perhaps it was the shooting, or his mother's death in 1972, that altered his outlook. Or perhaps Warhol liked the clarity his boyfriend brought to his home and the new streamlined Office. Warhol became a cataloguer of sorts. The dated, identical cardboard boxes create an illusion of order. However, it is a façade to the unsorted mass of memorabilia that lies inside.

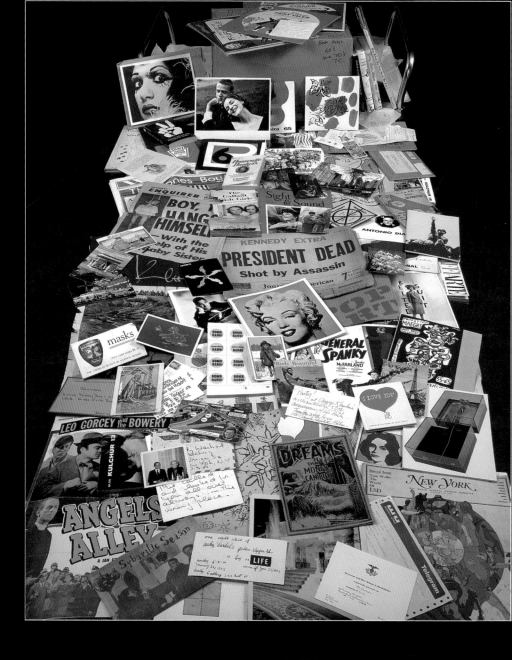

Time Capsule 44
Andy Warhol, 1973

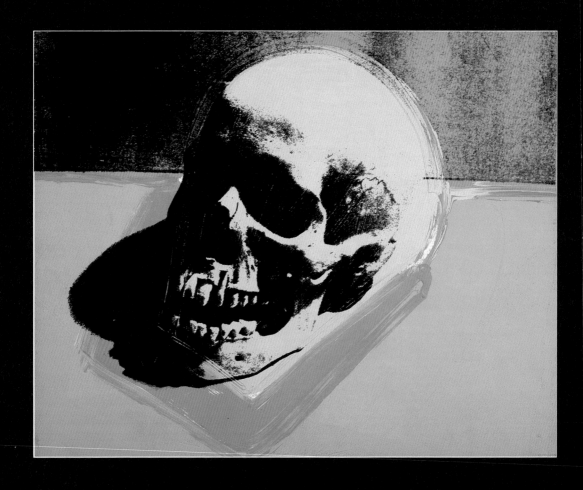

Skull
Andy Warhol, 1976

Synthetic polymer paint and silkscreen ink on canvas
15 × 19 in (38.1 × 48.26 cm)

Death revisited

In the 'Death and Disaster' series of the 1960s, death is somehow remote, involving unfamiliar people or god-like stars that never belonged on earth. In the 1970s, Warhol returns to the subject of death, but this time death sits uncomfortably close. Warhol had died and been brought back to life, and his scarred body was a constant reminder of his brush with death. He knew only too well that, 'Life is so quick, and sometimes it goes away too quickly.'

Drawn to the macabre, Warhol picked up a skull from an old flea market in Paris. The skull is the traditional 'memento mori' in painting – there to remind us of the transience of life. There is a Polaroid of Andy with the skull sitting on his shoulder. Historians have argued that such images suggest Warhol's acceptance of mortality, but I disagree. Death terrified Andy. He courts death only to defy it. The Polaroid of him with the skull is one of the jolliest images of Warhol. He literally laughs in the face of death, and the skull manages a nice, toothy grin back.

Warhol asked photographer Ronnie Cutrone to shoot the same skull from different angles, and he picked out one frame, which he used in his 'Skull' series. The selected frame is eerie. Cutrone noticed that the shadow cast by the skull looks like a foetus head, and so the beginning of life sits right beside death. Warhol forces the contrast between living and inanimate. Dramatic shadows round the cheeks and the temple suggest empty pits where the flesh has wasted away, while the clashing disco colours, like shock treatment, pulse high-octane energy back into the inanimate. We experience the night high of Studio 54, where Andy found life in the young and beautiful, the exhilarating throb of disco, and the pulsating light show. Near the end of life, he obscures the inevitable with a bit of Pop positivity. And why not? Death lurks close by.

In the Andy Warhol Museum a group of skull silkscreens hang in a line. Echoing the serial portraits of Ethel Scull, the palette varies in each canvas, but the spirit is very different. The exuberant Ethel is full of life, moving around and posing for the camera, while the series of repeated skulls, like a death knell, chime out for the dead.

Church boy

Typically, Warhol was evasive about his faith; asked whether he believed in God, he replied: 'I guess I do. I like church.' Even in the hedonistic heyday of the Silver Factory, Warhol was spotted at his neighbourhood church. After being shot, he began to attend mass at The Episcopal Church of Heavenly Rest, and worked as a volunteer in their soup kitchen. Later, when he moved to East 66th Street, he became a regular at Saint Vincent Ferrer, and liked to sit in the church when it was empty.

Warhol's late religious art is often overlooked. His series of crucifixes isolate the emblem of Christianity. Celebrating the faith of the ordinary man, he based the image on a modest, wooden cross – the type that is sold at the local worship shop, and held during mass.

The everyday icon is blown up into a monumental 7½-foot canvas. Carl Jung, the founder of analytical psychology, points to the universal resonance of the crucifix as a timeless symbol of acceptance and community. Warhol – the sickly child and the silent voyeur of the Silver scene – had consistently struggled to find his place in the world.

believing that: 'If I go into a hospital again, I won't come out. I won't survive another operation.' He met up with Brigid Berlin, who was about to go on a detox, and wanted Candy Andy to join her for a chocolate binge. But Candy Andy was in too much pain, and he 'just couldn't'.

On Tuesday 18 February, Warhol was in excruciating pain; however, he rose from his bed to attend the launch of a clothing collection by designer Kohshin Satoh at the Tunnel nightclub. The evening featured Warhol's favourite ingredients: an elite set, all the glamorous trappings and himself heading the show with Miles Davis. Warhol managed to survive the evening and left the club. In the last entry in his diary, he seems upbeat about the night, if a little jealous of Miles's outfit: '[they] sent the

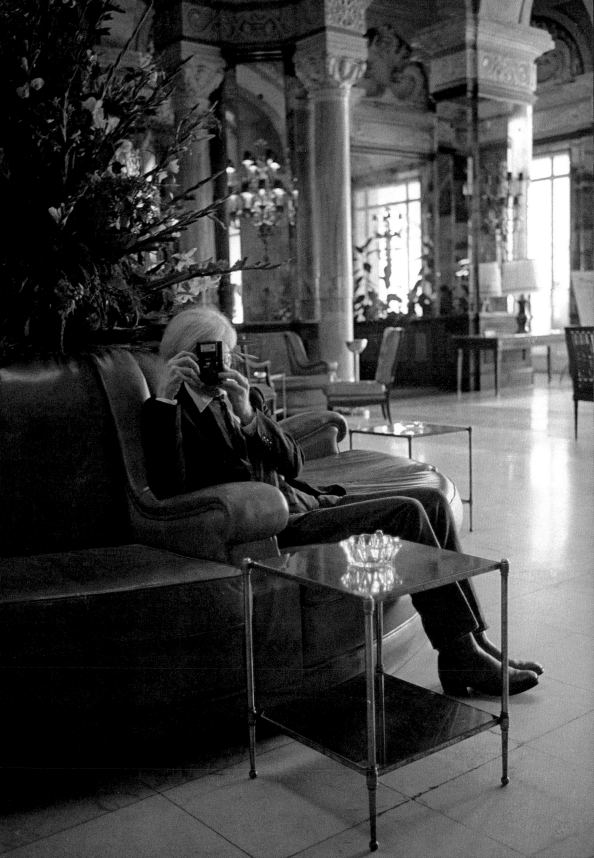

Picture Credits

Bibliography

'Andy Warhol's Mao', Christie's sales catalogue, 2006.

Angell, Callie. *Andy Warhol Screen Tests: The Films of Andy Warhol Catalogue Raisonné*, Abrams, 2006.

Barthes, Roland. *Camera Lucida: Reflections on Photography*, Vintage, 2000.

Baudrillard, Jean. *The System of Objects*, Verso, 2005.

Beyeler, Ernst, et al. *Andy Warhol: Series and Singles*, Yale University Press, 2000.

Colacello, Bob. *Holy Terror: Andy Warhol Close Up*, HarperCollins, 1990.

Danto, Arthur C. *Andy Warhol*, Yale University Press, 2009.

Dillenberger, Jane Daggett. *The Religious Art of Andy Warhol*, Continuum, 1998.

Galella, Ron. *Warhol by Galella, That's Great!* Monacelli Press, 2008.

Geldzahler, Henry and Robert Rosenblum. *Andy Warhol: Portraits of the Seventies and Eighties*, Thames & Hudson, 1993.

Goldsmith, Kenneth, ed. *I'll Be Your Mirror: The Selected Andy Warhol Interviews*, Carroll & Graf, 2004.

Guiles, Fred Lawrence. *Loner at the Ball: The Life of Andy Warhol*, Black Swan, 1990.

Haden-Guest, Anthony. *The Last Party: Studio 54, Disco, and the Culture of the Night*, William Morris & Company, Inc, 1997.

Hartley, Keith. *Andy Warhol: A Celebration of Life and Death*, National Galleries of Scotland, 2008.

Jung, Carl. *The Archetypes and the Collective Unconscious*, Routledge, 1991.

Koch, Stephen. *Stargazer: Andy Warhol's World and his Films*, Marion Boyars, 1985.

Lasch, Christopher. *The Culture of Narcissism: American Life in an Age of Diminishing Expectations*, W.W. Norton & Company, 1991.

McLuhan, Marshall. *The Medium is the Massage*, Penguin, 1967.

Name, Billy. *All Tomorrow's Parties*, DAP/Frieze, 1997.

Sontag, Susan. *On Photography*, Penguin, 1977.

Stein, Jean. *Edie: An American Biography*, Alfred A. Knopf, 1982.

Ultra Violet, *Famous for 15 Minutes: My Years with Andy Warhol*, Mandarin Press, 1988.

Warhol, Andy. *Andy Warhol: Portraits of the 70s*, Random House, 1980.

Warhol, Andy. *'Giant' Size*, Phaidon, 2009.

Warhol, Andy. *The Philosophy of Andy Warhol: From A to B and Back Again*, Harcourt Brace Jovanovich, 1977.

Warhol, Andy and Pat Hackett. *POPism: The Warhol Sixties*, Harcourt Brace Jovanovich, 1980.

Watson, Steven. *Factory Made: Warhol and the Sixties*, Pantheon Books, 2003.

Acknowledgements

For Matthew, with love.

A heartfelt thanks to Laurence King for taking on this nutty project, and I am extremely grateful to Angus Hyland for his creative direction. I would like to thank Jo Lightfoot for her continual support, Melissa Danny for her thoughtful direction and careful editing, and Julia Ruxton for sourcing such great images. Thanks to Jason Ribeiro for all his work on the design, and Melanie Mues for her creative contribution. A big thanks to Andrew Rae, who backed the project from the beginning. I am also very grateful to Sara Roveta for her encouragement and support in the early stages of the project, and Jo Marsh for all her generous suggestions.

I would like to thank my mum and dad for their support over the years. Thanks Lulu and Sam for all the fun times.

Catherine Ingram, 2013

Catherine Ingram

Catherine is a freelance art historian. She obtained a First Class Honours degree at Glasgow University, where she was a Honeyman scholar. After an MA in 19th-century art at the Courtauld Institute of Art, Catherine became a graduate scholar at Trinity College, Oxford. After finishing her D.Phil, she was made a Prize Fellow at Magdalen College, Oxford. Catherine has taught on the MA course at Christie's and lectured at Imperial College, teaching art history to undergraduate scientists. She has also run courses at the Tate Gallery and was a personal assistant at South London Gallery. She lives with her family in London.

Andrew Rae

Andrew is an illustrator and member of the illustration collective Peepshow. He studied at Brighton University and has worked for many clients worldwide in advertising, print, publishing and animation. He currently lives and works in London.